# List of Paintings
## in the
## STERLING AND FRANCINE CLARK ART INSTITUTE

# List of Paintings
## in the
## STERLING AND FRANCINE CLARK ART INSTITUTE

---

**Sterling and Francine Clark Art Institute**
Williamstown, Massachusetts

Sterling and Francine Clark Art Institute,
summer, 1991

Editing: Steven Kern, Curator of
    Paintings
Production: Mary Jo Carpenter, Director
    of Public Relations and Membership
Photography: Arthur Evans and Merry
    Armata, Clark Art Institute/
    Williamstown Regional Art Conser-
    vation Laboratory Photographic
    Facility
Design: Deborah Hewitt
Typesetting and Printing: Excelsior
    Printing

**Library of Congress
Cataloging-in-Publication Data**

Sterling and Francine Clark Art Institute.
  List of paintings in the Sterling and
  Francine Clark Art Institute [editing,
  Steven Kern; photography, Arthur Evans
  and Merry Armata].
    p.    cm.
  Includes indexes.
  ISBN 0-931102-31-6 (paper)
  1. Painting — Massachusetts —
Williamstown — Catalogs. 2. Sterling and
Francine Clark Art Institute — Catalogs.
I. Kern, Steven. II. Title.
N867.A6  1992
750'.74'7441 — dc20                    92-6127
                                          CIP

**Cover:** Claude Monet, *Tulip Fields at
Sassenheim, near Leiden* (detail)

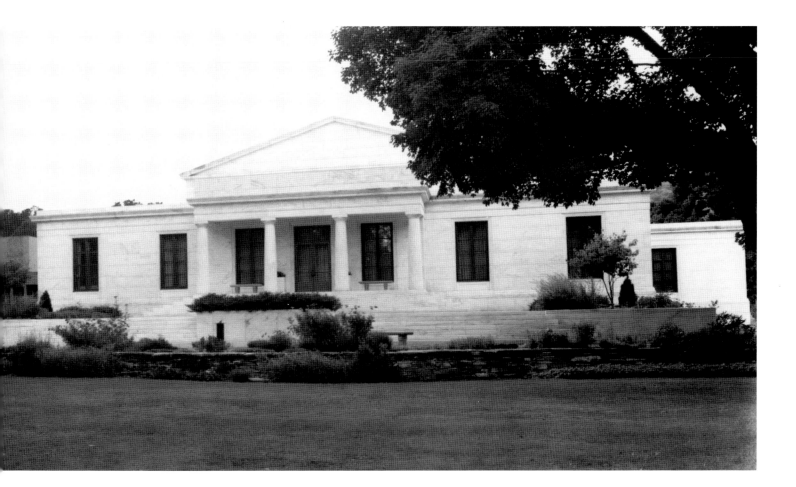

# Contents

# Acknowledgments

In 1971 the task of publishing the first *List of Paintings in the Sterling and Francine Clark Art Institute* was undertaken. The effort, which was spearheaded by Fiona Morgan under the leadership of former director George Heard Hamilton, resulted eighteen months later in the publication of the first fully illustrated list of paintings belonging to the Clark. By the early '80s, the success of the book was proven when it became clear that it would soon be out of print. Rather than reprint the 1972 edition, it was decided to update information, to add works acquired in the meantime, and to give the list a whole new look. This was all accomplished in 1984 by the curatorial staff — David Cass, Jennifer Gordon, and Beth Carver Wees — with the guidance of Director David S. Brooke.

Ten years later, in early 1991, we faced the same problem. Knowing the 1984 list of paintings would soon be out of print, the staff decided once again to update rather than simply reprint. This list of paintings reflects any changes in title or attribution since 1984, especially in the American paintings collection, which was the subject of a separate annotated catalogue, published in 1990. This list also includes all works that have entered the collections from 1984 through the end of 1991.

The standardization and verification of names, nationalities, and dates are never easy. The pain was lessened with the assistance of two very important organizations. I would like to thank BHA, the Bibliography of the History of Art (Bibliographie de l'Histoire de l'Art), for their valuable advice, particularly Associate Editor Gillian H. Lewis and Assistant Editors for Research, Carol Cusano and Mary Ann McSweeny. The Centre de Documentation du 19e Siècle at the Musée d'Orsay, Paris, and Anne Roquebert, research curator at that museum, provided verification of French names.

I would also like to thank my colleagues here at the Clark for their patience and opinions on all aspects of this latest list of paintings: Beth Carver Wees, curator of decorative arts; Rafael Fernandez, curator of prints and drawings; Jennifer Gordon Lovett, associate curator of paintings and sculpture; Patricia Ivinski, curatorial assistant; Martha Asher, registrar; Sarah Gibson, librarian; Paige Carter, catalogue librarian; Dustin Wees, slide and photograph librarian; Elizabeth Kieffer, slide cataloguer. Three graduate students helped with this project: Anna Gado from the University of Virginia and Carla Grosse and Gabriela Lobo-Tamez from the Williams College Graduate Program in the History of Art. All tasks, large and small, were cheerfully attended to by all three.

Six people at the Clark require special recognition for their assistance with this project: Lisa Jolin, curatorial secretary, especially for her ability to keep track of photographs and their labels; photographers Merry Armata and Arthur Evans for their fine work behind the camera; Brian O'Grady, museum shop manager, for his gentle prodding; Mary Jo Carpenter, director of membership and public relations, for her drive and energy in seeing this project through every step of production; and David S. Brooke, director, for his support and encouragement and all the other obvious reasons. Finally, thanks to Deborah Hewitt who, with a smile, has completed the herculean chore of designing the catalogue, and to Excelsior Printing Company of North Adams for their fine job.

STEVEN KERN
Curator of Paintings
February 1992

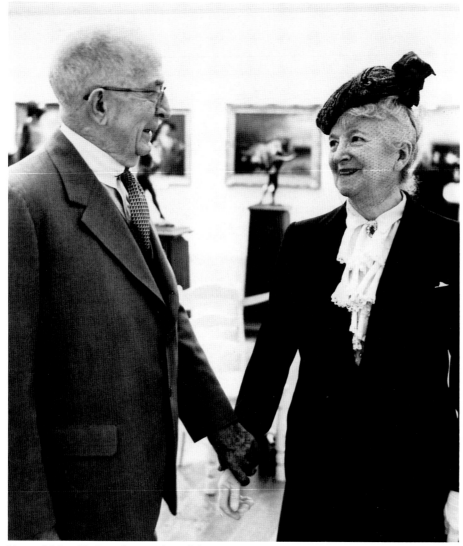

Mr. and Mrs. Clark at the opening of the Institute, May 1955

# A Personal Collection

When the Sterling and Francine Clark Art Institute opened its doors to the public for the first time in May 1955, very little was known about either the Clarks or their collection. Even now, the Clarks retain most of the privacy that they cherished so much, and scarcely anything of an authoritative nature has been written about them. Since most of the paintings illustrated here were acquired by them, a brief sketch of the formation and character of their collection may serve as a useful introduction to this publication.

In his unpublished memoir of Robert Sterling Clark (1877-1956), Charles Durand-Ruel mentions that Clark kept something of a military manner about him throughout his life. In fact Clark was a soldier before he became a collector. He served in the United States Army from 1899 to 1905 and shortly thereafter organized an expedition to northern China, about which he published a book in 1912. It was apparently about 1912 that he bought a house in Paris and started to address himself seriously to acquiring works of art. To judge from his letters at the time, collecting soon became a passion, rivaled only by his love for horses and his search for books on military and equestrian subjects. His enthusiasm for works of art had presumably been conditioned in part by the collection of his parents, Alfred Corning Clark and Elizabeth Scriven Clark, which included paintings by Robert Blum, Jean-François Millet, and Jean-Léon Gérôme. Robert Sterling Clark was certainly dissatisfied by the way in which this collection was divided among himself and his brothers after his mother's death in 1910. He expressed this concern in several letters to his brother Stephen and went to considerable lengths to recapture some of his parents' pictures: he bought back Géricault's *Trumpeter of the Hussars* from his brother Ambrose in 1913, and more than twenty-five years later he discovered Gérôme's *Snake Charmer* in the art market noting, ''There was the painting as fine as I remembered — academic, yes, tight, yes, but what drawing and mastery of the art.''

Robert Sterling Clark seems to have been briefly advised at the start of his collecting career by George Gray Barnard, a sculptor who had been launched by Alfred Corning Clark. Robert had already acquired several old master paintings when Stephen and he engaged Barnard to act as their guide and agent on an art-buying tour of Europe in the spring of 1913 (a trip during which he acquired in Florence the portrait by Domenico Ghirlandaio). This seems to have been the first and only time that he relied on another's advice, and his letters to Stephen from Paris between 1913 and 1916 already show the vigorous independence of opinion which was to mark his collecting throughout his life. For example, he once wrote,

> I would not have given over ten thousand dollars for the two [Whistler] portraits that Frick bought at such an enormous price and if I had I should have sold them the day after.

Clark was somewhat skeptical of critics, museum curators, and art historians. He felt a greater affinity with other collectors and especially with dealers. Much of his collecting pleasure came from conversations with his acquaintances ''in the trade''; he enjoyed their practical involvement with art, their gossip, and their salesmanship. He regarded his favorite firms, Knoedler's and Durand-Ruel, rather like friendly clubs, where he ''jollyed-up'' their employees and reacted with enthusiasm to what he considered ''fancy pictures.'' When dealers remarked, as they sometimes did, that Clark should have been in the trade himself, he took it as a high compliment.

Alfred Corning Clark had been a private patron of the arts, and his son Robert was no less private a collector. He did not choose to associate himself with museums. He had a small circle of friends, showed his collection to

few, and lent his pictures rarely—and then only anonymously. He delighted in the publicity that Bouguereau's *Nymphs and Satyr* aroused when it was exhibited at Durand-Ruel in 1943 to raise money for the Fighting French Relief, but he never confessed to owning it. Even after Clark had decided to turn his very private collection into a public museum, he remained remarkably reticent. He issued no personal statements to the press when the Institute opened in 1955 and granted scarcely any interviews. He had written earlier to a friend, "Do not mention the opening of the Institute to anyone, as you will treat me to a cloud of newspapermen to the detriment of my health." Perhaps this very privacy is mirrored in the content of some of his pictures. He and his wife liked domestic subjects: figures in interiors reading, playing music, or simply resting.

Hilaire Germain Edgar Degas, *Before the Race*

Yet another aspect of this privacy is that his pictures were bought with his own pleasure in mind, with apparently little thought of building an "important" and eventually public collection. When Lionello Venturi called him to account for admiring Gérôme, Clark noted to himself,

> A funny lot these art historians — they know art history, the stories of painters, study their special manners of painting but for an eye which appreciates all kinds of artists who are craftsmen they lack that entirely in many cases.

He always attached more importance to looking at works of art. To an acquaintance who asked him what to read to appreciate pictures, he gave this advice,

> I told her to look, look and look again and not let herself be influenced by anyone in her likes and dislikes! That there was no book on art which was not biased, and experts were so many "bluffs," that they only like pictures which were in fashion.

It is scarcely surprising that the collection of such a man would be as idiosyncratic as he was. It is heavily weighted in favor of French painting, especially of the later nineteenth century, and it stops around 1900. While Clark admired some works by Cézanne, Seurat, Vuillard, and Redon, he acquired nothing by them, and his taste did not extend to Picasso, Matisse, and their contemporaries. The collection is dominated by his "favorites," and his acquisition of their paintings spanned wide periods: Renoir (Clark bought his works between the years 1916 and 1950), Homer (1916-54), Degas (1919-48), Corot (1919-47), Stevens (1920-53), and Boldini (1924-41).

William Bouguereau, *Seated Nude*

His pre-eighteenth-century pictures—Italian, Flemish, and Dutch—were mainly acquired between 1912 and 1925 through the London firm of Colnaghi's; he made further purchases, however, in these areas through the 1940s. An early interest in French eighteenth-century painting and in the Barbizon school increased during the 1920s at the same time that his purchases of the older, non-French artists were decreasing. While a fascination with Degas and Renoir developed early in his collecting, his interest in impressionist landscape painting really began with the purchase of three Monets, six Renoirs, and a Pissarro in 1933. Three of the four Lautrecs, the four Sisleys, five of the seven Pissarros, three of the six Monets, the two Cassatts, and the Morisot were all acquired in the last fifteen years of his life. It is interesting to speculate whether the acquisitions made after the early 1940s, when the Institute was firmly set in his mind, might reflect "institutional" as well as personal taste.

Bouguereau and Gérôme entered the collection together with their more avant-garde contemporaries. Clark apparently found nothing incongruous about buying Degas's *Before the Race* and Bouguereau's *Seated Nude* at the same time in 1938. He also had a fascination with cabinet pictures, beginning with the purchases of a Meissonier (1919), a Stevens (1920), and a Boldini (1924). He referred to this type of painting as "my little pictures of the 1880s" and candidly admired them for what they were—precious, well

painted, and anecdotal.

Clark acquired almost half of his collection from Knoedler's, who sold him nearly all his paintings by Sargent, Homer, Remington, Stevens, and Boldini. Another fifth of his paintings—including twenty-four Renoirs and three works by Degas—came from Durand-Ruel, a firm with which he felt a close personal connection. Charles Durand-Ruel vividly recalled Clark's frequent visits to their premises on what the latter referred to as ''the 57th Street Art Island'':

> When a painting captured his imagination, he brandished the cane he usually carried with him, twirling it and pointing at the canvas, much to the alarm of our faithful porters, who adored him since he treated them as old friends.

When he started collecting, Robert Sterling Clark proposed to his brother Stephen that they establish a museum in their hometown, Cooperstown, New York. As the collection grew, he considered in turn leaving it to the Louvre, the Virginia Museum of Fine Arts, and New York's Metropolitan Museum of Art. It was only in the 1940s, when he and his wife were in their sixties, that Clark began seriously to consider setting up his own institution. He seems to have settled on Williamstown for various reasons: its relative ''safety,'' a family association with Williams College, and a friendship with Professor Karl Weston, then director of the Williams College Museum of Art.

While it was he, rather than his wife Francine (1876-1960), who was the more informed and active collector, Clark always consulted her and valued her opinions highly. They visited the dealers together frequently, and we find them at Wildenstein's in 1940 discussing the merits of Toulouse-Lautrec's splendid oil of Jane Avril:

> I could see that Francine was impressed and very much so. I asked how much. Felix Wildenstein said $45,000 to me, asking $55,000. Expensive, yes; but a fancy picture and probably worth it today. We got as far as the corner. Francine was very strong for buying the Jane Avril — a chef d'oeuvre she said. We returned and said we would take it.

Robert Sterling Clark entered with much relish into the planning of his new museum, and his life was happily capped by a double triumph, the winning of the Epsom Derby in 1954 and the opening of his Institute in the following year. How characteristic of Clark that he had named his horse Never Say Die, and that at the time of his own passing in 1956 he was still busily planning the installation of the collection whose acquisition had given him so much pleasure.

DAVID S. BROOKE
Director

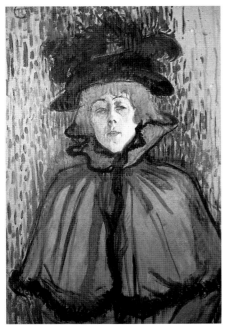

Henri de Toulouse-Lautrec, *Jane Avril*

# Notes to the Reader

The *List of Paintings at the Sterling and Francine Clark Art Institute* is arranged alphabetically by artist, and paintings by the same artist are listed alphabetically by title. Each entry is accompanied by a photograph of the work of art.

## Artist

All of the attributions in this list reflect the current status of research on the Clark painting collection. The following terms and definitions are used to refer to the authorship of works which are associated with a specific artist, but which may be wholly or partially by another hand:

| | |
|---|---|
| **School or Studio of** | a work by a pupil of the artist, possibly under the supervision of the artist. |
| **Follower of** | a work of the period of the artist and closely related to his style. |
| **In the style of** | a work in the manner of the artist, possibly of a later period. |
| **After** | a copy of the work of the artist. |

## Nationality

All artists have been assigned a nationality. This poses certain problems, especially with artists who traveled extensively or worked in areas where historical and contemporary boundaries do not match. All decisions on nationality reflect the current status of research.

## Title

All titles are given in English. Foreign titles with special meaning are retained but accompanied by a simple translation into English. The title usually reflects the title the artist is known to have given the piece or under which it was first exhibited. Alternative titles, which have appeared in art-historical literature or in early records on the work but which are not used by the Clark, have been omitted in this list.

## Date

The date of the work, when known, immediately follows the title. A *circa* (c.) date followed by a single year indicates a leeway of five years before and after that date; a *circa* date followed by a span of years indicates that the work was executed sometime between the two dates.

## Medium

The medium and support of all objects are included in this list. Pastels are included if the entire surface has been worked; otherwise, they have traditionally been classified as drawings and are published as such.

## Dimensions

Dimensions are given in inches followed by centimeters in parentheses; height precedes width.

## Inscriptions

All visible signatures, dates, and other inscriptions are included in this list and are in the artist's hand unless otherwise noted. The use of upper and lower case letters reflects the actual appearance of the inscription. Line division is indicated by a slash.

## Numbering and Credit Lines

The Clark Art Institute uses two numbering systems. An accession number without a decimal (from one to four digits, originally inventory numbers) indicates that the painting was purchased by Mr. and Mrs. Clark and is part of the original collection. Works purchased after 1955, when the Institute opened, are numbered by the year of purchase followed by a decimal and a number that was assigned chronologically to all works entering the collection in that year. All works given to the Clark Art Institute bear a credit line that respects the wishes of the donor.

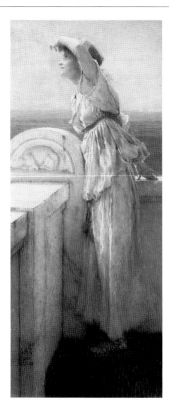

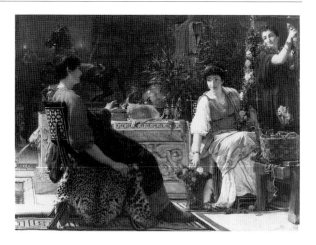

**Alma-Tadema, Lawrence**
British, 1836-1912

*Hopeful,* 1909
Oil on panel
13⅜ x 5⁷⁄₁₆ (34 x 13.9)
Signed and inscribed lower left:
LAT/op./CC,CXCIV
Number 873

**Alma-Tadema, Lawrence**
British, 1836-1912

*Preparations for the Festivities,* 1866
Oil on canvas
21¹⁄₁₆ x 27³⁄₁₆ (53.5 x 69)
Signed center: L. ALMA. TADEMA.
Bequest of Madeleine Dahlgren
Townsend
Number 1982.11

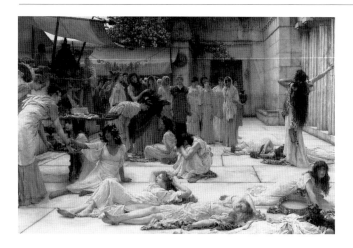

**Alma-Tadema, Lawrence**
British, 1836-1912

*The Women of Amphissa,* 1887
Oil on canvas
48 x 72 (121.9 x 182.9)
Signed and inscribed lower right
in tambourine: L Alma-Tadema
op. CCLXXVIII
Number 1978.12

**American School**
19th-20th Century

*Autumn Landscape*
Oil on canvas
20 x 25 (50.8 x 63.5)
Number 1025

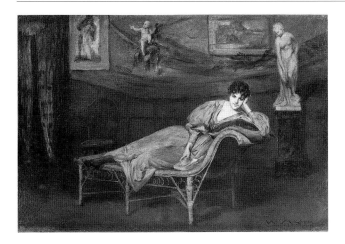

**American School**
19th-20th Century

*Lady Reclining,* c. 1890-1900
Oil on canvas
14⅛ x 21¹⁄₁₆ (35.9 x 53.5)
Falsely signed lower right:
Wm. M. Chase
Number 675

**American School**
19th-20th Century

*Washington's Headquarters,
Valley Forge,* after 1890
Oil on academy board
16⅝ x 20⅝ (42.2 x 52.4)
Number 885

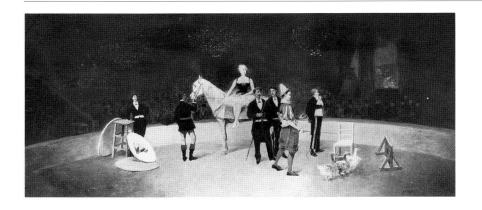

**Atalaya, Enrique**
Spanish, died c. 1914

*Circus Scene*
Oil on panel
6½ x 14⅞ (16.5 x 37.8)
Signed lower right: ATALAYA.
Number 635

**Aubry, Etienne**
French, 1745-1781

*Les adieux à la nourrice*
(Farewell to the Nurse)
Oil on canvas
20⁷⁄₁₆ x 24¾ (51.9 x 62.8)
Number 636

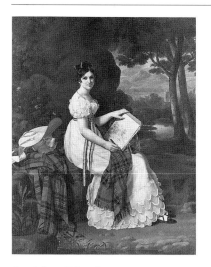

**Austrian School**
19th Century

*Woman Sketching in a Landscape,*
c. 1830
Oil on canvas
51⅜ x 38⅝ (130.5 x 98)
Number 1982.60

**Baer, William Jacob**
American, 1860-1941

*Alfred Corning Clark,* 1893 and 1911
Oil on canvas
22¹⁄₁₆ x 18 (56 x 45.7)
Signed and dated upper right:
Wᵐ J. Baer/1893·1911
Number 637

**Barbour**
French (?), 20th Century

*Lady Reading*
Oil on board
8¼ x 10⁹⁄₁₆ (21 x 26.9)
Signed lower right: Barbour.
Number 638

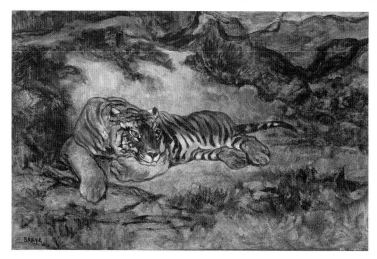

**Baré, Edouard**
French, active 1872

*The Tuileries Gardens*
Oil on panel
8⅝ x 6³⁄₁₆ (22 x 15.8)
Signed lower right: E. BARÉ.
Number 639

**Barye, Antoine-Louis**
French, 1796-1875

*Tiger*
Oil on paper mounted on canvas
12⅛ x 18¼ (30.8 x 46.3)
Signed lower left: BARYE
Number 640

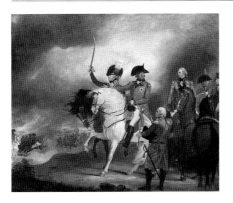

**Beechey, William**
British, 1753-1839

*King George III Reviewing the Prince of Wales' Regiment of Light Dragoons, Attended by the Prince of Wales, the Duke of York and Other General Officers,* c. 1794

Oil on canvas
46⁵⁄₁₆ x 56³⁄₁₆ (117.6 x 142.7)
Gift of Herbert P. Patterson, Casimir de Rham, Jr., and David P. de Rham
Number 1969.26

**Beers, Jan van**
Belgian, 1852-1927

*A Woman in Evening Dress*
Oil on canvas
10¹³⁄₁₆ x 14 (27.5 x 35.6)
Signed and inscribed lower right:
A L'AMI CANONNE/JAN VAN BEERS
Number 888

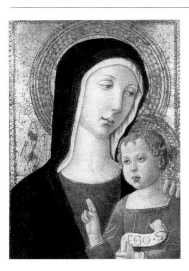

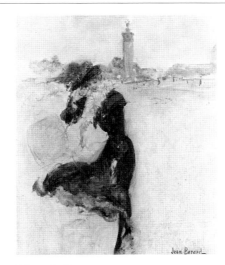

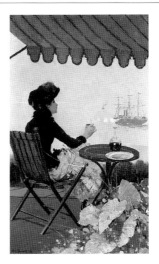

**Benvenuto di Giovanni**
Italian (Sienese), 1436-c. 1518

*Virgin and Child*
Tempera on panel
16¹⁄₁₆ x 11¾ (40.8 x 29.8)
Number 933

**Béraud, Jean**
French, 1849-1936

*The Red Dress*
Oil on panel
13¹⁄₁₆ x 10½ (33.2 x 26.7)
Signed lower right: Jean Béraud
Number 663

**Béraud, Jean**
French, 1849-1936

*Seaside Café,* 1884
Oil on canvas
21⅝ x 13³⁄₁₆ (55 x 33.5)
Signed and dated lower left:
Jean Béraud 84
Number 641

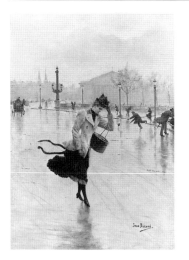

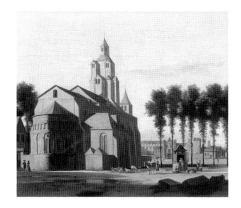

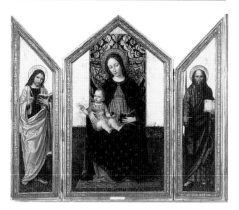

**Béraud, Jean**
French, 1849-1936

*A Windy Day, Place de la Concorde*
Oil on panel
22$\frac{1}{16}$ x 14$\frac{13}{16}$ (56 x 37.6)
Signed lower right: Jean Béraud.
Number 642

**Berckheyde, Gerrit Adriaensz.**
Dutch, 1638-1698

*Church of Saint Cecelia, Cologne*
Oil on canvas
20$\frac{3}{8}$ x 24$\frac{1}{4}$ (51.8 x 61.6)
Signed lower left: G. Berck Heyde
Bequest of C. C. Cunningham
Number 1980.15

**In the style of
Bergognone (Ambrogio da Fossano,
called Il Bergognone)**
Italian (Milanese), active 1481-1522

*Virgin and Child with Saints John the
Evangelist and Paul*
Oil on panel
Center panel 37$\frac{9}{16}$ x 21$\frac{1}{8}$ (95.5 x 53.7);
side panels approximately 35$\frac{3}{8}$ x 7$\frac{5}{8}$
(90 x 19.5)
Number 1024

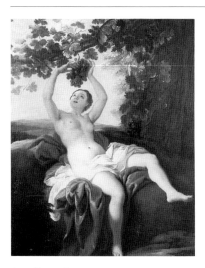

**Attributed to
Berthélemy, Jean-Simon**
French, 1743-1811

*Erigone*
Oil on canvas
27$\frac{1}{4}$ x 20$\frac{3}{16}$ (69.3 x 51.3)
Number 710

**Biard, François**
French, c. 1798-1882

*A Sudden Squall at Sea*
Oil on canvas
31$\frac{5}{8}$ x 38$\frac{15}{16}$ (80.3 x 98.9)
Signed lower left: Biard;
signed lower right: Biard
Number 643

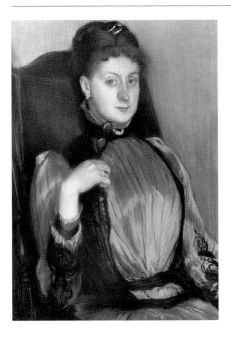

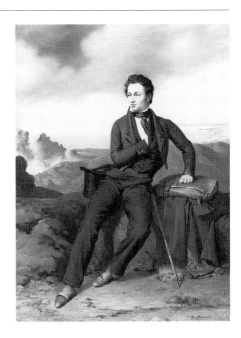

**Blanche, Jacques Emile**
French, 1861-1942

*Portrait of a Lady,* 1890
Pastel on linen
32¾ x 23 (83 x 58.5)
Signed, dated, and inscribed lower
left: JEB [monogram] 90/Paris
Number 1983.48

**Bodinier, Guillaume**
French, 1795-1872

*Portrait of Théodore Jubin,* 1826
Oil on canvas
20⅜ x 14⅜ (51.6 x 36.5)
Signed, dated, and inscribed lower
right: G. Bodinier/Rome 1826
Number 1985.12

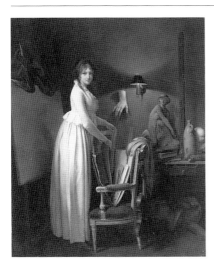

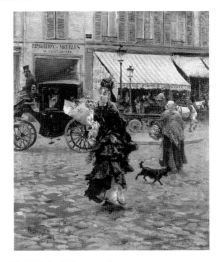

**Boilly, Louis-Léopold**
French, 1761-1845

*The Artist's Wife in His Studio*
Oil on canvas
16¹⁄₁₆ x 12¾ (40.8 x 32.5)
Number 646

**Boilly, Louis-Léopold**
French, 1761-1845

*Trompe l'oeil,* 1785
Oil on canvas
28⁹⁄₁₆ x 23¹³⁄₁₆ (72.5 x 60.5)
Signed upper left: f. Boilly
Number 1981.1

**Boldini, Giovanni**
Italian, 1842-1931

*Crossing the Street,* 1875
Oil on panel
18¹⁄₁₆ x 14¾ (45.9 x 37.5)
Signed and dated lower left:
Boldini/75
Number 650

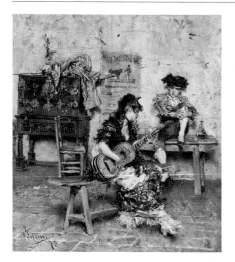

**Boldini, Giovanni**
Italian, 1842-1931

*A Guitar Player,* 1873
Oil on canvas
16¼ x 13½ (41.3 x 34.3)
Signed and dated lower left:
Boldini/73
Number 651

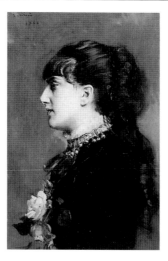

**Boldini, Giovanni**
Italian, 1842-1931

*Madame Leclanche,* 1881
Oil on canvas
23¾ x 15¹⁵⁄₁₆ (60.3 x 40.4)
Signed and dated upper left:
Boldini/1881
Number 649

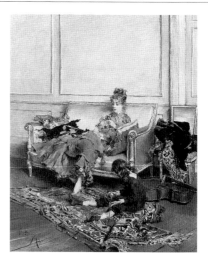

**Boldini, Giovanni**
Italian, 1842-1931

*Peaceful Days,* 1871
Oil on canvas
14¼ x 10¹³⁄₁₆ (36.1 x 27.4)
Signed and dated lower left:
Boldini/71
Number 648

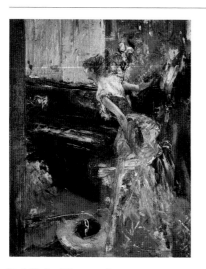

**Boldini, Giovanni**
Italian, 1842-1931

*Recital*
Oil on panel
8⁹⁄₁₆ x 6⅜ (21.8 x 16.2)
Inscribed upper left: [5?] 6
Number 652

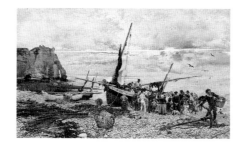

**Boldini, Giovanni**
Italian, 1842-1931

*The Return of the Fishing Boats,
Etretat,* 1879
Oil on panel
5½ x 9⁵⁄₁₆ (14 x 23.7)
Signed and dated lower left:
Boldini–79
Number 647

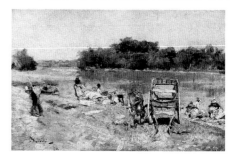

**Boldini, Giovanni**
Italian, 1842-1931

*Washerwomen,* 1874
Oil on panel
5⅜ x 7¹³⁄₁₆ (13.6 x 19.9)
Signed and dated lower left:
Boldini–/74
Number 653

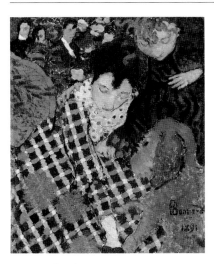

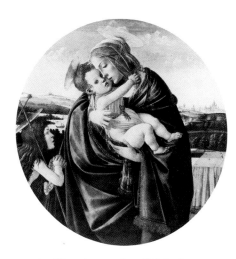

**Bonnard, Pierre**
French, 1867-1947

*Women with Dog,* 1891
Oil on canvas
16 x 12¾ (40.6 x 32.4)
Signed and dated lower right:
PBonnard [PB monogram]/1891
Number 1979.23

**Botticelli (Alessandro di Mariano
Filipepi) and Studio**
Italian (Florentine), c. 1447-1510

*Virgin and Child with Saint John the
Baptist,* c. 1490
Tempera with some oil on panel
Diameter 34⅞ (88.6)
Number 930

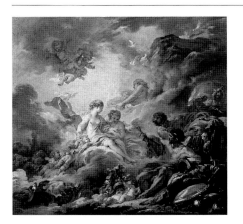

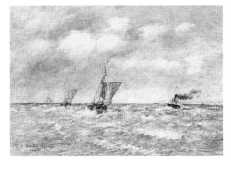

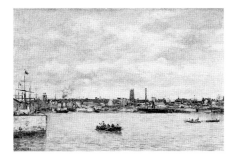

**Boucher, François**
French, 1703-1770

*Vulcan Presenting Arms to Venus
for Aeneas,* 1756
Oil on canvas
16¹³⁄₁₆ x 17⅞ (41.2 x 45.3)
Signed and dated lower right:
f. Boucher/1756
Purchased in memory of Talcott M.
Banks, Jr., Institute Trustee 1950-77;
President 1966-77
Number 1983.29

**Boudin, Eugène**
French, 1824-1898

*Boats Returning to Port, Trouville,*
1894
Oil on canvas
25¾ x 36⅜ (65.4 x 92.4)
Signed, dated, and inscribed lower
left: E. Boudin–94/Trouville
Bequest of Mrs. Osborne Howes
Number 1973.7

**Boudin, Eugène**
French, 1824-1898

*Dunkerque,* 1889
Oil on canvas
14¼ x 23 (36.2 x 58.5)
Signed, dated, and inscribed lower
left: Dunkerque/E Boudin 89.
Number 535

**Boudin, Eugène**
French, 1824-1898

*Rue Saint-Romain, Rouen,* 1895
Oil on panel
18⅛ x 14⅞ (46 x 37.8)
Signed and dated lower left: E Boudin
95; inscribed lower right: Rouen/27 7
[illegible] Romain [?]
Number 540

**Boudin, Eugène**
French, 1824-1898

*Villefranche,* c. 1890-92
Oil on panel
16 1/16 x 12⅞ (40.8 x 32.7)
Signed and inscribed lower right:
Villefranche/E. Boudin
Number 547

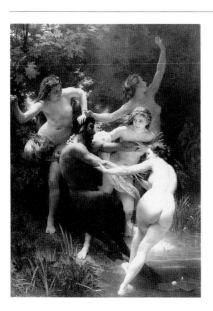

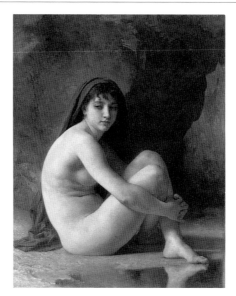

**Bouguereau, William**
French, 1825-1905

*Nymphs and Satyr,* 1873
Oil on canvas
102⅜ x 70⅞ (260 x 180)
Signed and dated lower left:
W–BOUGUEREAU–1873
Number 658

**Bouguereau, William**
French, 1825-1905

*Seated Nude,* 1884
Oil on canvas
45⅞ x 35⅜ (116.5 x 89.8)
Signed and dated upper right:
W–BOUGUEREAU–1884
Number 659

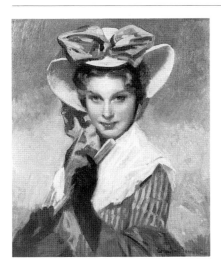

**Boulet, Cyprien Eugène**
French, 1877-1927

*La parisienne*
(The Parisian Woman)
Oil on canvas
25½ x 21⁵⁄₁₆ (64.8 x 54.1)
Signed lower right: Cyprien. Boulet
Number 660

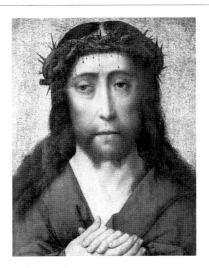

**School of
Bouts, Dirck, the Elder**
Netherlandish, born before 1448-1475

*Christ Crowned with Thorns*
Tempera with oil highlights on panel
15³⁄₈ x 11⁵⁄₈ (39 x 29.6)
Number 936

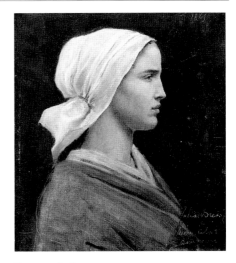

**Breton, Jules**
French, 1827-1906

*Jeanne Calvet,* 1865
Oil on board
8⁵⁄₈ x 7⁷⁄₁₆ (21.9 x 18.9)
Signed and inscribed lower right:
Jules Breton/Jeanne Calvet/
Douarnenez/Sardinière;
dated upper right: 1865
Number 661

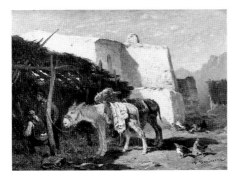

**Brissot de Warville, Félix Saturnin**
French, 1818-1892

*Spanish Donkeys*
Oil on panel
7⁵⁄₈ x 10⁵⁄₈ (19.4 x 27)
Signed lower right: F. Brissot.
Number 662

**British School**
19th Century

*Lane to the Village*
Oil on canvas
12¼ x 10¹⁄₁₆ (31.1 x 25.6)
Number 657

**British School**
19th Century

*Parachute and Her Foal*
Oil on canvas
23⁷⁄₈ x 31¹⁵⁄₁₆ (60.7 x 81.1)
Number 884

**British School**
19th Century

*River Scene, Rouen*
Oil on panel
3⁷⁄₁₆ x 4⅝ (8.8 x 11.8)
Number 654

**British School**
19th Century

*River Scene, Rouen*
Oil on panel
3½ x 4⁹⁄₁₆ (8.9 x 11.7)
Number 655

**British School**
19th Century

*Rouen*
Oil on canvas
11⅞ x 14⅞ (30.2 x 37.8)
Number 656

**Bylant, A. de**
British, active 1853-1874

*Boats*
Oil on panel
8¼ x 12¼ (20.7 x 30.9)
Signed lower right: A de Bylandt
Number 698

**Byzantine (or Greek)**
15th-16th Century (?)

*The Entry of Christ into Jerusalem*
Tempera on panel
15¾ x 10⅜ (40 x 26.3)
Number 951

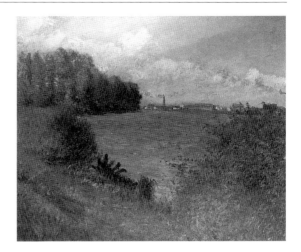

**Cabot, Edward Clark**
American, 1818-1901

*The Levee*, 1866
Oil on academy board
9¼ x 18¹⁵⁄₁₆ (23.5 x 48.1)
Signed and dated lower left:
CC [monogram]/66
Number 666

**Caillebotte, Gustave**
French, 1848-1894

*The Seine at Argenteuil*, c. 1885
Oil on canvas
21⁵⁄₁₆ x 25⅝ (54.1 x 65.1)
Signed lower left: G Caillebotte
Gift of George Heard Hamilton
and Polly W. Hamilton
Number 1973.35

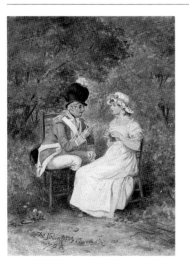

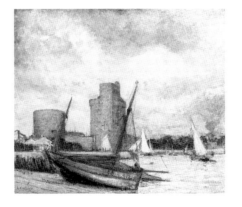

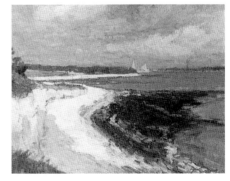

**Caldecott, Randolph**
British, 1846-1886

*The Volunteer's Courtship*
Oil on board
15¹⁵⁄₁₆ x 10⅞ (40.5 x 27.7)
Signed, dated, and inscribed
lower left: R C/The Volunteer's
Courtship/1798
Number 667

**Callot, Henri-Eugène**
French, 1875-1956

*Harbor Scene*
Oil on board
19¹¹⁄₁₆ x 24 (50.1 x 61)
Signed lower left: h. Callot
Number 669

**Callot, Henri-Eugène**
French, 1875-1956

*The Port of La Rochelle*
Oil on canvas
18⁵⁄₁₆ x 24¹⁄₁₆ (46.5 x 61.1)
Signed lower left: h CALLOT
Number 668

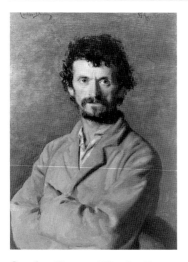

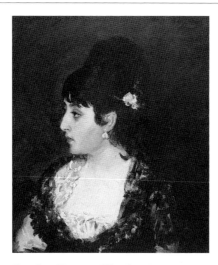

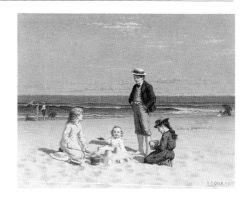

**Carolus-Duran (Charles Durant)**
French, 1837-1917

*The Artist's Gardener,* 1893
Oil on canvas
31⅞ x 21¹¹⁄₁₆ (81 x 55.1)
Signed upper left: Carolus-Duran.;
dated and inscribed upper right:
St Aygulf, O^bre 1893.
Number 40

**Carolus-Duran (Charles Durant)**
French, 1837-1917

*Spanish Lady,* 1876
Oil on panel
10½ x 8¼ (26.7 x 21)
Signed upper left: Carolus-Duran.;
dated upper right: 1876.
Number 671

**Carr, Samuel S.**
American, 1837-1908

*Children Playing on the Beach,* 1879
Oil on canvas
8 x 10 (20.3 x 25.4)
Signed and dated lower right:
S. S. CARR. 79.
Number 672

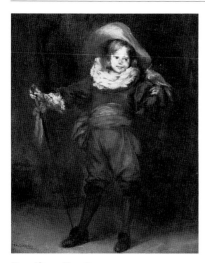

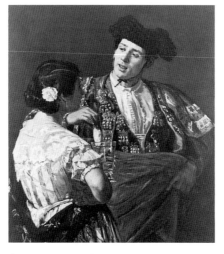

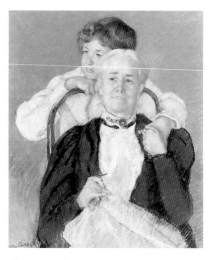

**Carrière, Eugène**
French, 1849-1906

*Le petit d'Artagnan*
(Little d'Artagnan)
Oil on canvas
13⅞ x 10⅝ (35.3 x 27)
Signed lower left: EUG. CARRIERE
Number 673

**Cassatt, Mary Stevenson**
American, 1844-1926

*Offrant le panal au torero,* 1873
(Offering the Panale to the Bullfighter)
Oil on canvas
39⅝ x 33½ (100.6 x 85.1)
Signed, dated, and inscribed lower
right: Mary S. Cassatt./Seville./1873.
Number 1

**Cassatt, Mary Stevenson**
American, 1844-1926

*Portrait of Mrs. Cyrus J. Lawrence
with Grandson R. Lawrence Oakley,*
c. 1898-99
Pastel on paper
28 x 23 (71.1 x 58.4)
Signed lower left: Mary Cassatt
Gift of Mrs. R. Lawrence Oakley
Number 1973.36

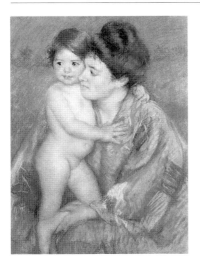

**Cassatt, Mary Stevenson**
American, 1844-1926

*Woman with Baby,* c. 1902
Pastel on paper
28⅜ x 20⅞ (72.1 x 53)
Signed lower right: Mary Cassatt
Gift of the Executors of Governor
Lehman's Estate and the Edith and
Herbert Lehman Foundation
Number 1968.301

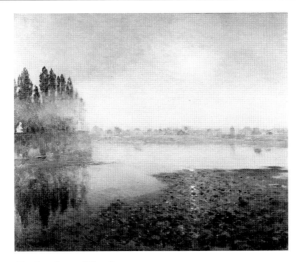

**Cazin, Jean-Charles**
French, 1841-1901

*Mist on the River*
Oil on canvas
21½ x 25⅞ (54.6 x 65.7)
Signed lower left: J. C. CAZIN
Number 1026

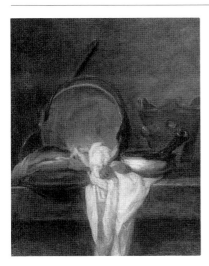

**Chardin, Jean-Baptiste Siméon**
French, 1699-1779

*Cooking Pots and Ladle with a White
Cloth,* c. 1728-30
Oil on canvas
15⅜ x 12⅛ (39.1 x 30.8)
Signed lower left on edge of ledge:
chardin
Number 1975.17

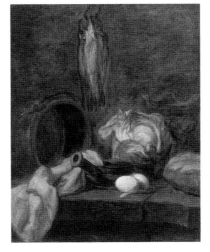

**Chardin, Jean-Baptiste Siméon**
French, 1699-1779

*Kitchen Utensils and Three Herrings or
Whitings,* c. 1728-30
Oil on canvas
15⅜ x 12⅛ (39.1 x 30.8)
Signed lower left on edge of ledge:
chardin
Number 1975.16

**Chartran, Théobald**
French, 1849-1907

*Emma Calvé as Carmen,* 1894
Oil on canvas
45¹¹⁄₁₆ x 35½ (116.1 x 90.2)
Signed and dated lower right:
Chartran/-1894-
Number 41

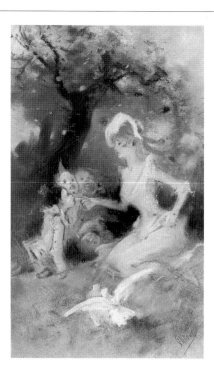

**Chase, William Merritt**
American, 1849-1916

*Portrait of Eilif Peterssen,* c. 1875
Oil on canvas
24 x 19 (61 x 48.3)
Signed and dated upper left: 187[5?]
and traces of signature
Gift of Asbjorn R. Lunde
Number 1980.43

**Chéret, Jules**
French, 1836-1932

*Spring,* c. 1890
Pastel on paper
22¼ x 12⅞ (56.5 x 32.8)
Signed lower right: J. Chéret [JC
interlaced]
Number 676

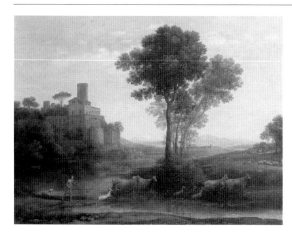

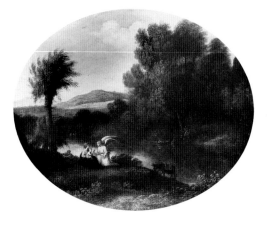

**Claude Lorrain (Claude Gellée)**
French, 1600-1682

*Landscape with the Voyage
of Jacob,* 1677
Oil on canvas
28 x 37⅞₆ (71.2 x 95.1)
Signed, dated, and inscribed left
center: CLAUDIO IVF/ROMA 1677
Number 42

**Claude Lorrain (Claude Gellée)**
French, 1600-1682

*Rest on the Flight into Egypt*
Oil on panel
12¹¹⁄₁₆ x 14¹⁵⁄₁₆ (32.2 x 38)
Signed and inscribed lower right:
CLAUDIO IVF/ROMA
Number 677

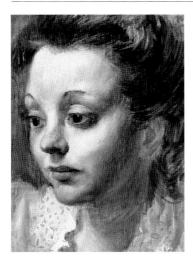

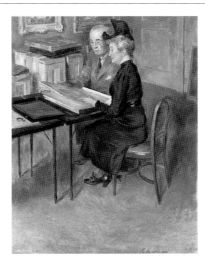

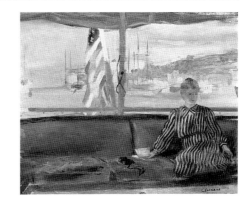

**Clemens, Paul Louis**
American, born 1911

*Head of Ruth,* c. 1941
Oil on wood
8 x 5$^{15}$/$_{16}$ (20.3 x 15.1)
Number 928

**Clemens, Paul Louis**
American, born 1911

*Mr. and Mrs. Clark,* 1967 after 1942
original
Oil on canvas
19$^{3}$/$_{16}$ x 14$^{1}$/$_{4}$ (48.7 x 36.2)
Signed lower right: Clemens
Number 1967.84

**Clemens, Paul Louis**
American, born 1911

*Mrs. Clark on a Yacht,* 1947
Oil on canvas
9$^{15}$/$_{16}$ x 11$^{7}$/$_{8}$ (25.2 x 30.2)
Signed lower right: Clemens
Number 679

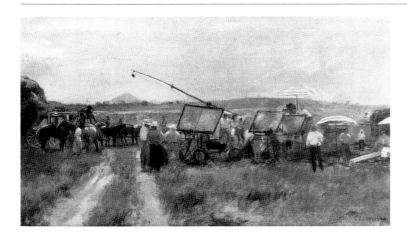

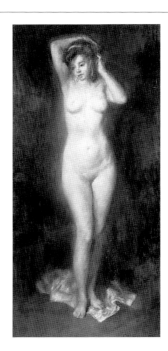

**Clemens, Paul Louis**
American, born 1911

*Movie Sketch,* 1948
Oil on canvas
7 x 12 (17.8 x 30.5)
Signed lower right: Clemens
Number 681

**Clemens, Paul Louis**
American, born 1911

*Nude,* 1942
Oil on board
22 x 10$^{1}$/$_{2}$ (55.9 x 26.7)
Signed and dated lower right:
Clemens 42.
Number 927

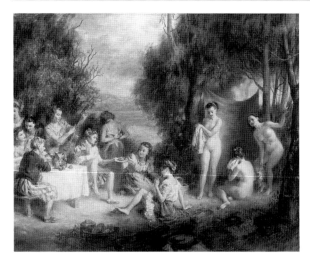

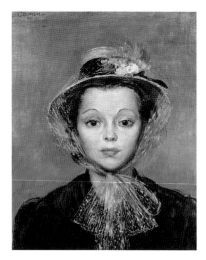

**Clemens, Paul Louis**
American, born 1911

*Pastorale*, 1945
Oil on canvas
29 x 36 (73.7 x 91.4)
Signed and dated lower left:
Clemens/1945
Number 922

**Clemens, Paul Louis**
American, born 1911

*Ruth in Blue Bonnet*, 1941
Oil on wood
20¾ x 16¼ (52.7 x 41.3)
Signed and dated upper left:
Clemens/1941.
Number 921

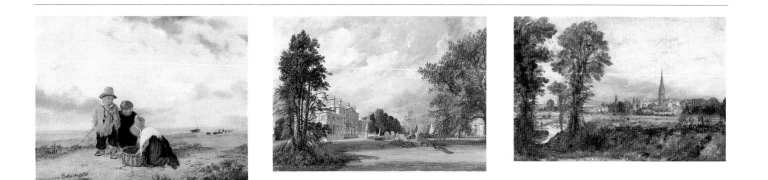

**Collins, William**
British, 1788-1847

*Children on the Beach*
Oil on canvas
9³⁄₁₆ x 12 (23.4 x 30.5)
Number 682

**Constable, John**
British, 1776-1837

*Malvern Hall*, 1821
Oil on canvas
21⁵⁄₁₆ x 30¾ (54.2 x 78.2)
Number 683

**Follower of
Constable, John**
British, 1776-1837

*Distant View of Salisbury Cathedral*
Oil on paper mounted on panel
6¾ x 9¹⁵⁄₁₆ (17.2 x 25.5)
Number 684

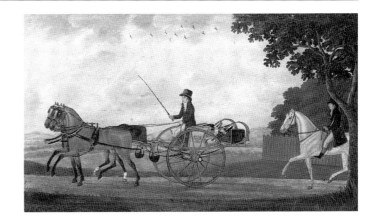

**Cook, Clarence G.**
American, 1853-1934

*Wooded Grove,* 1890
Oil on canvas
16¹⁄₁₆ x 22¹⁵⁄₁₆ (40.8 x 58.3)
Signed and dated lower right:
Clarence Cook./90
Number 1032

**Cordrey, John**
British, active 1765-1825

*Pair in Trotting Gig,* 1800
Oil on paper mounted on panel
10⁹⁄₁₆ x 18⁵⁄₁₆ (26.9 x 46.6)
Signed and dated lower left:
by J. Cordrey.1800
Number 685

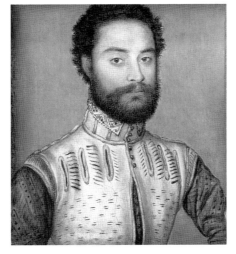

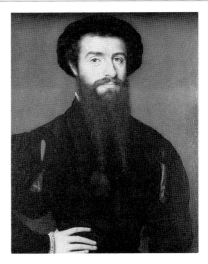

**Corneille de Lyon (Corneille de la Haye)**
French, c. 1500-c. 1574

*François de Montmorency* (?)
Oil on panel
7³⁄₈ x 6⁵⁄₁₆ (18.8 x 16)
Number 686

**Corneille de Lyon (Corneille de la Haye)**
French, c. 1500-c. 1574

*Sir John Chichester* (?)
Oil on panel
7⁹⁄₁₆ x 6⁵⁄₈ (19.2 x 16.9)
Number 687

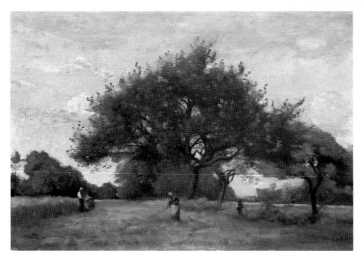

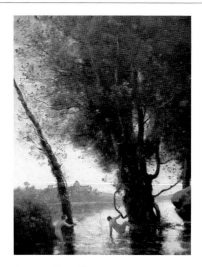

**Corot, Camille**
French, 1796-1875

*Apple Trees in a Field,* c. 1865-71
Oil on canvas
16 x 23⅞ (45 x 60.7)
Signed lower right: COROT
Number 548

**Corot, Camille**
French, 1796-1875

*The Bathers of the Borromean Isles,*
c. 1865-70
Oil on canvas
31 x 22⅛ (78.7 x 56.2)
Signed lower left: COROT
Number 537

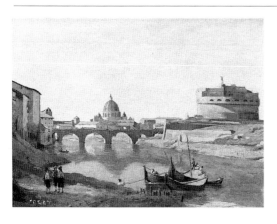

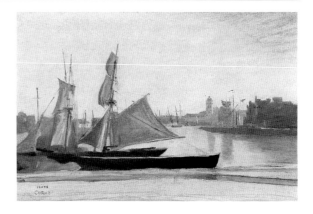

**Corot, Camille**
French, 1796-1875

*The Castel Sant'Angelo, Rome,*
c. 1835-40
Oil on canvas
13⁷⁄₁₆ x 18⁵⁄₁₆ (34.2 x 46.5)
Signed lower left: COROT/COROT/Corot
Number 555

**Corot, Camille**
French, 1796-1875

*Dunkerque: Fishing Boats Tied to the Wharf,* c. 1829-30
Oil on canvas
9¼ x 14³⁄₁₆ (23.6 x 36.1)
Stamped lower left: VENTE/COROT
Number 542

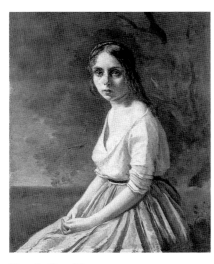

**Corot, Camille**
French, 1796-1875

*Girl in a Pink Skirt,* c. 1845-50
Oil on canvas
18⅞ x 15⅜ (47.9 x 39.1)
Number 541

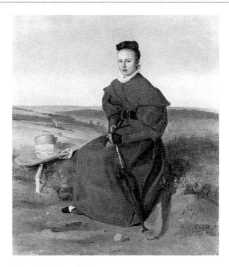

**Corot, Camille**
French, 1796-1875

*Louise Harduin in Mourning,* 1831
Oil on canvas
21⅜ x 18¹⁄₁₆ (54.3 x 45.9)
Signed and dated lower right:
C. Corot./1831
Number 539

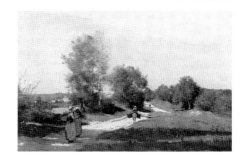

**Corot, Camille**
French, 1796-1875

*A Road by the Water,* c. 1865-70
Oil on canvas
15¾ x 25⁹⁄₁₆ (40 x 60.5)
Signed lower right: COROT
Number 553

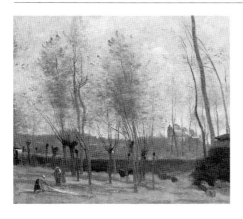

**Corot, Camille**
French, 1796-1875

*Washerwomen in a Willow Grove,*
1871
Oil on canvas
15 x 18⅛ (38.1 x 46.1)
Signed lower left: Corot
Number 526

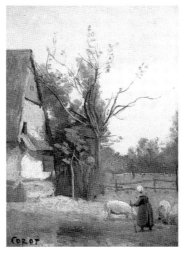

**Follower of
Corot, Camille**
French, 1796-1875

*Barnyard Scene*
Oil on canvas
13⅜ x 9⁷⁄₁₆ (34 x 24)
Falsely signed lower left: COROT
Number 538

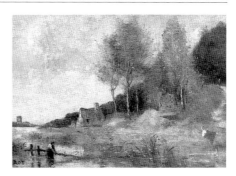

**Follower of
Corot, Camille**
French, 1796-1875

*Marsh at Boves, near Amiens*
Oil on canvas
9⁷⁄₁₆ x 13⅞ (24 x 35.3)
Falsely signed lower left: COROT
Number 546

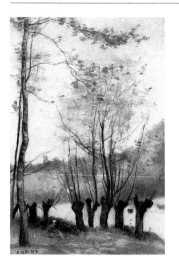

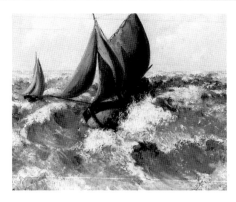

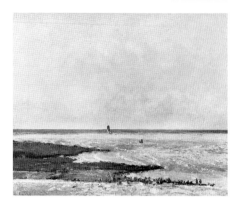

**Follower of
Corot, Camille**
French, 1796-1875

*Meadow with Willows, Monthléry*
Oil on canvas
13¾ x 8¹¹⁄₁₆ (35 x 22.1)
Falsely signed lower left: COROT
Number 689

**Courbet, Gustave**
French, 1819-1877

*Seascape*
Oil on canvas
21 x 25⅜ (53.4 x 64.5)
Signed lower left: G. Courbet.
Number 690

**Courbet, Gustave**
French, 1819-1877

*The Seaweed Gatherers,* 1865
Oil on canvas
21⁵⁄₁₆ x 25¾ (54.2 x 65.5)
Signed lower left: G. Courbet
Number 527

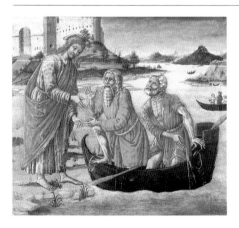

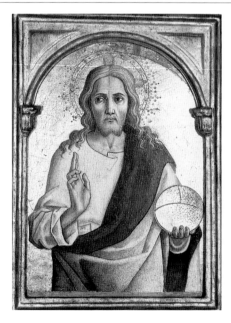

**Cozzarelli, Guidoccio di Giovanni**
Italian (Sienese), active 1450-1517

*The Calling of Saints Peter and
Andrew*
Tempera with some oil on panel
11½ x 12⅞ (29.3 x 32.7)
Number 931

**Crivelli, Carlo**
Italian (Venetian), c. 1430-c. 1495

*Salvator Mundi,* c. 1470-72
Tempera possibly with some oil on
panel
12⅝ x 9³⁄₁₆ (32 x 23.4)
Number 932

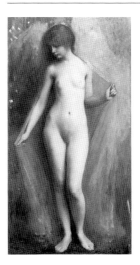

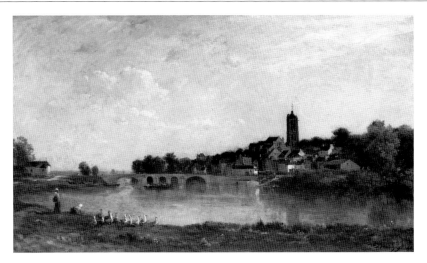

**Dagnan-Bouveret, Pascal
Adolphe Jean**
French, 1852-1929

*Primavera: Nude,* 1914
Oil on canvas
68⅚₆ x 34¾ (173.5 x 88.3)
Signed and dated lower left:
PAJ·DAGNAN-B/1914....
Number 43

**Daubigny, Charles-François**
French, 1817-1878

*The Bridge between Persan and
Beaumont-sur-Oise,* 1867
Oil on panel
15¹⁄₁₆ x 26½ (38.2 x 67.3)
Signed and dated lower right:
Daubigny 1867
Number 694

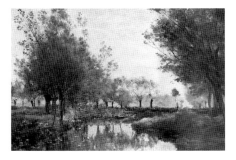

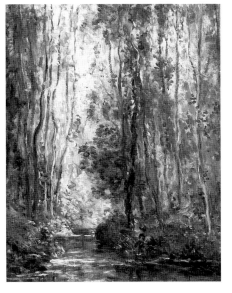

**Daubigny, Charles-François**
French, 1817-1878

*Landscape,* 1863
Oil on panel
12¼ x 19⅜ (31.2 x 49.3)
Signed and dated lower right:
Daubigny 1863.
Number 693

**Daubigny, Charles-François**
French, 1817-1878

*Woodland Scene,* 1873 (?)
Oil on panel
9 x 6¹⁵⁄₁₆ (22.9 x 17.6)
Signed and dated lower right:
Daubigny 187[?]
Number 695

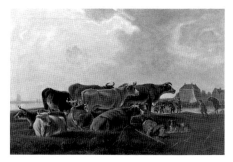

**Daumier, Honoré**
French, 1808-1879

*An Artist*
Oil on panel
13⅞ x 10⅝ (35.3 x 27)
Signed lower left: h. D.
Number 697

**Daumier, Honoré**
French, 1808-1879

*The Print Collectors,* c. 1860-63
Oil on panel
12⁵⁄₁₆ x 15¹⁵⁄₁₆ (31.2 x 40.5)
Signed lower right: h. Daumier
Number 696

**Day, Horace Talmage**
American, 1909-1984

*Landscape with Cattle,* 1934
Oil on canvas
28 x 42⅞ (71.1 x 108.9)
Signed, dated, and inscribed lower
right: copy of Cuyp/by Horace
DAY–/1934
Gift of the children of
Mrs. E. Parmalee Prentice
Number 1962.153

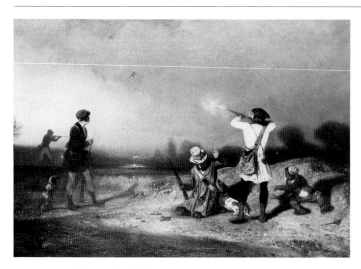

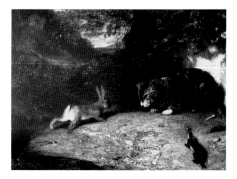

**Decamps, Alexandre Gabriel**
French, 1803-1860

*Bird Shooting,* 1830
Oil on canvas
13¹¹⁄₁₆ x 19¹³⁄₁₆ (34.7 x 50.3)
Signed lower center: Decamps.
Number 701

**Decamps, Alexandre Gabriel**
French, 1803-1860

*Cat, Weasel, and Rabbit,* 1836
Oil on canvas
9⁹⁄₁₆ x 13⁷⁄₁₆ (24.3 x 34.2)
Signed and dated lower left:
DECAMPS/1836
Number 699

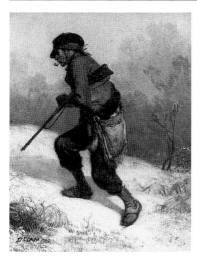

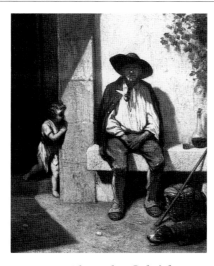

**Decamps, Alexandre Gabriel**
French, 1803-1860

*The Poacher*
Oil on canvas
9½ x 7¼ (24.1 x 18.5)
Signed lower left: DECAMPS
Number 700

**Decamps, Alexandre Gabriel**
French, 1803-1860

*The Wayfarer*, 1842
Oil on canvas
15½ x 12⅜ (39.4 x 31.5)
Signed and dated lower left:
DECAMPS 1842
Number 702

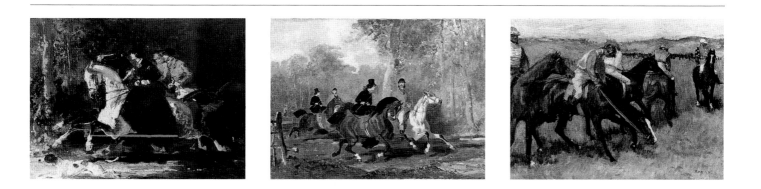

**Dedreux, Alfred**
French, 1810-1860

*Equestrians*
Oil on canvas
9½ x 12¹³⁄₁₆ (24.1 x 32.6)
Signed lower right: Alfred D.D.
Number 721

**Dedreux, Alfred**
French, 1810-1860

*Equestrians in the Forest at Compiègne*
Oil on canvas
13 x 18⁷⁄₁₆ (33.1 x 46.9)
Signed lower right: Alfred D. Dreux
Number 722

**Degas, Hilaire Germain Edgar**
French, 1834-1917

*Before the Race*, c. 1882
Oil on panel
10⁷⁄₁₆ x 13¾ (26.5 x 34.9)
Signed lower right: Degas
Number 557

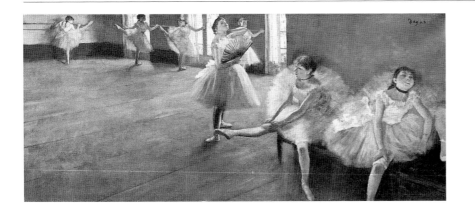

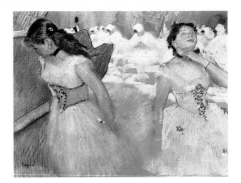

**Degas, Hilaire Germain Edgar**
French, 1834-1917

*The Dancing Lesson,* c. 1880
Oil on canvas
15½ x 34¹³⁄₁₆ (39.4 x 88.4)
Signed upper right: degas
Number 562

**Degas, Hilaire Germain Edgar**
French, 1834-1917

*The Entrance of the Masked Dancers,*
1884
Pastel on paper
19⁵⁄₁₆ x 25½ (49 x 64.7)
Signed lower left: Degas
Number 559

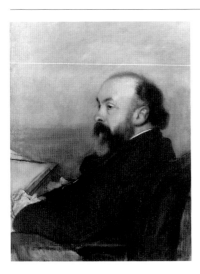

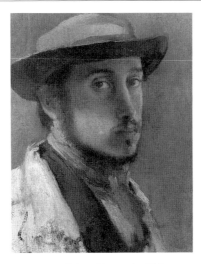

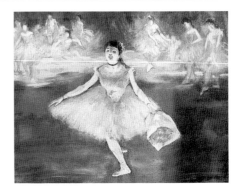

**Degas, Hilaire Germain Edgar**
French, 1834-1917

*Portrait of a Man,* 1875-80
Oil on canvas
31¼ x 23 ⁵⁄₁₆ (79.3 x 59.3)
Stamped lower left: degas
Number 44

**Degas, Hilaire Germain Edgar**
French, 1834-1917

*Self-Portrait,* c. 1857-58
Oil on paper mounted on canvas
10¼ x 7½ (26 x 19)
Number 544

**Follower of**
**Degas, Hilaire Germain Edgar**
French, 1834-1917

*Dancer with a Bouquet*
Pastel on paper mounted on
cardboard
20⅛ x 25¹⁵⁄₁₆ (51.2 x 65.9)
Falsely signed lower left: Degas
Number 549

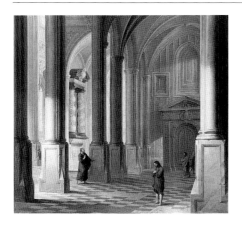

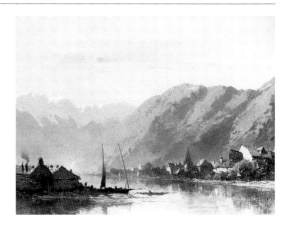

**Delen, Dirck van**
Dutch, 1605-1671

*Church Interior with the Parable of the Pharisee and the Publican,* 1653
Oil on panel
19⁷⁄₁₆ x 22 (49.4 x 55.9)
Signed and dated lower right on column: DV[monogram]DELEN F 1653.
Gift of Asbjorn R. Lunde
Number 1981.63

**Deshayes, Eugène**
French, 1828-1890

*A Swiss Lake*
Oil on canvas
9⁹⁄₁₆ x 12¹¹⁄₁₆ (24.3 x 32.3)
Signed lower left: Eug. Deshayes
Number 711

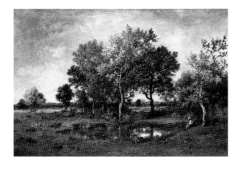

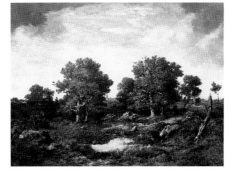

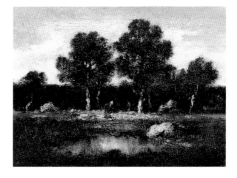

**Diaz de la Peña, Narcisse**
French, 1807-1876

*Forest Clearing,* 1869
Oil on canvas
14¹³⁄₁₆ x 21¹⁵⁄₁₆ (37.6 x 55.7)
Signed and dated lower left:
n. DiaZ. 69 —
Number 712

**Diaz de la Peña, Narcisse**
French, 1807-1876

*Landscape,* 1854
Oil on canvas
16¹³⁄₁₆ x 22⅜ (42.7 x 56.8)
Signed and dated lower left:
n. DiaZ. 54.
Number 714

**Diaz de la Peña, Narcisse**
French, 1807-1876

*Trees near Barbizon*
Oil on panel
5¹⁄₁₆ x 7⅛ (12.9 x 18.1)
Number 713

**Domergue, Jean Gabriel**
French, 1889-1962

*Monsieur Caillaux,* 1926
Oil on board
21⅝ x 18⅛ (55 x 46)
Signed and dated lower right:
jean/gabriel/domergue/26
Number 718

**Domergue, Jean Gabriel**
French, 1889-1962

*Portrait of Francine J. M. Clark,* 1936
Oil on canvas
21¾ x 18¼ (55.2 x 46.3)
Signed lower right:
jean/gabriel/domergue
Number 719

**Domergue, Jean Gabriel**
French, 1889-1962

*Portrait of Robert Sterling Clark,* 1936
Oil on canvas
21¾ x 18⅛ (55.2 x 46)
Signed lower right:
jean/gabriel/domergue
Number 720

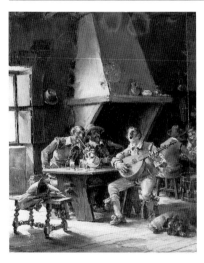

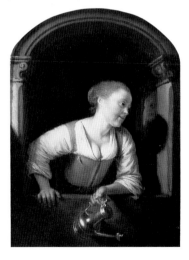

**Domingo y Marqués, Francisco**
Spanish, 1842-1878

*Drinking Song*
Oil on panel
7⁵⁄₁₆ x 5¹¹⁄₁₆ (18.6 x 14.5)
Signed lower left: F Domingo
Number 715

**Dou, Gerard**
Dutch, 1613-1675

*Girl at a Window*
Oil on panel
10⁹⁄₁₆ x 7½ (26.9 x 19)
Signed lower left: G DOU
[GD monogram]
Number 716

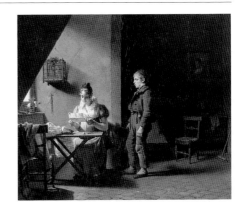

**Douglas, William Fettes**
British, 1822-1891

*Women in Church*
Oil on board
8 x 9¹⁵⁄₁₆ (20.4 x 25.3)
Number 717

**Drölling, Martin**
French, 1752-1817

*Madame Dugazon*
Oil on canvas
17¹⁵⁄₁₆ x 14¾ (45.5 x 37.5)
Signed lower left: drölling f.
Number 725

**Drölling, Martin**
French, 1752-1817

*The Messenger*, 1815
Oil on canvas
17¹⁵⁄₁₆ x 22 (45.5 x 55.8)
Signed and dated lower left:
Drölling.f 1815
Number 724

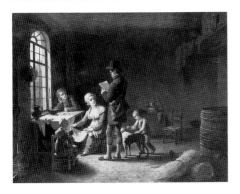

**Drölling, Martin**
French, 1752-1817

*Le procès-verbal*, 1816
(The Statement)
Oil on panel
11⅜ x 14⅜ (28.9 x 36.5)
Signed and dated lower left:
drölling/1816
Number 723

**Dubourg, Victoria**
French, 1840-1926

*Roses*
Oil on canvas
13⅛ x 16¼ (33.3 x 41.2)
Signed lower right: V D
Number 726

**Dupré, Jules**
French, 1811-1889

*Landscape*
Oil on panel
8¹¹⁄₁₆ x 10⅞ (22.1 x 27.7)
Number 727

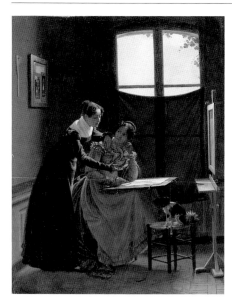

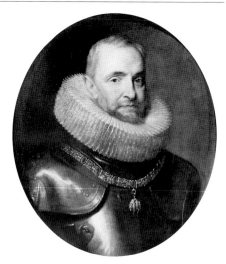

**Duval-Lecamus, Pierre**
French, 1790-1854

*Drawing Lesson,* c. 1826
Oil on canvas
12¹³⁄₁₆ x 9¹¹⁄₁₆ (32.6 x 24.6)
Signed and dated lower left:
Duval.Lecamus 182[6?]
Number 728

**Dyck, Anthony van**
Flemish, 1599-1641

*Ambrogio da Spinola,* c. 1620
Oil on canvas
26½ x 22⅛ (68 x 56.2)
Number 27

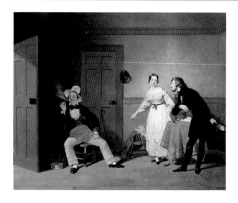

recto

verso

**Edmonds, Francis William**
American, 1806-1863

*The City and Country Beaux,* c. 1838-40
Oil on canvas
20⅛ x 24¼ (51.1 x 61.6)
Signed on stool: Edmonds
Number 915

**Edmonds, Francis William**
American, 1806-1863

Recto: *Study for "The City and
Country Beaux";* verso: *Study for an
Unidentified Painting,* c. 1838
Oil on board
4¼ x 5¼ (10.8 x 13.3)
Number 1987.109

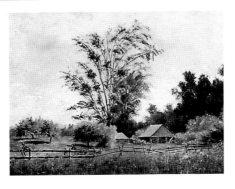

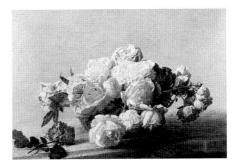

**Edmonds, Francis William**
American, 1806-1863

*Sparking,* 1839
Oil on canvas
19¹⁵⁄₁₆ x 24 (50.6 x 61)
Signed and dated lower right:
F W Edmonds/1839
Number 916

**Eilshemius, Louis Michel**
American, 1864-1941

*American Farm,* 1900
Oil on canvas
12 x 16⅛ (30.5 x 41)
Signed lower right: Elshemus.; dated
lower left: 1900
Number 730

**Fantin-Latour, Henri**
French, 1836-1904

*Bowl of Roses on a Marble Table,* 1885
Oil on canvas
14⁷⁄₁₆ x 21¹⁄₁₆ (36.7 x 53.5)
Signed and dated lower right:
Fantin. 85
Number 920

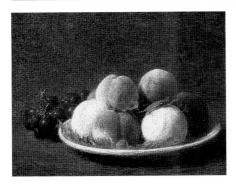

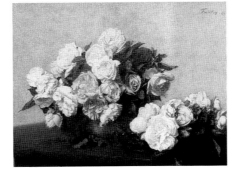

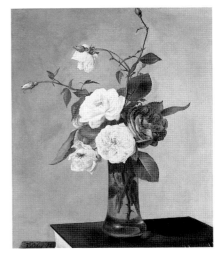

**Fantin-Latour, Henri**
French, 1836-1904

*Peaches and Grapes*
Oil on canvas
10⅞ x 14³⁄₁₆ (27.6 x 36.1)
Signed lower left: Fantin
Number 732

**Fantin-Latour, Henri**
French, 1836-1904

*Roses in a Bowl and Dish,* 1885
Oil on canvas
18 x 24⅞ (45.8 x 63.2)
Signed and dated upper right:
Fantin. 85
Number 734

**Follower of
Fantin-Latour, Henri**
French, 1836-1904

*Roses in a Vase*
Oil on canvas
17½ x 14¾ (44.4 x 37.5)
Falsely signed and dated lower left:
Fantin-72-
Number 733

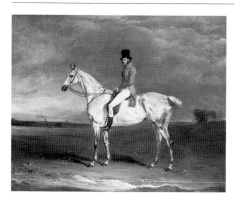

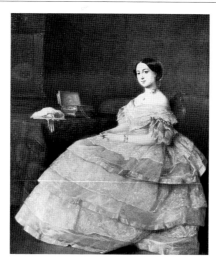

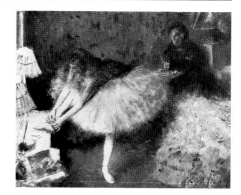

**Ferneley, John E.**
British, 1781-1860

*Duchess,* 1831
Oil on canvas
33⅞ x 42⅜ (86 x 107.7)
Signed and dated lower right:
J Ferneley/Melton Mowbray/1831.;
inscribed lower center: DUCHESS.
Number 924

**Fichel, Eugène**
French, 1826-1895

*A Girl in Pink,* 1857
Oil on panel
9⁹⁄₁₆ x 7¼ (24.3 x 18.5)
Signed and dated lower left:
E. FICHEL./1857.
Number 735

**Forain, Jean-Louis**
French, 1852-1931

*Dancer in Her Dressing Room*
Oil on panel
10⁷⁄₁₆ x 13¾ (26.6 x 35)
Signed lower right: j. l forain
Number 738

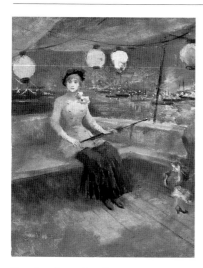

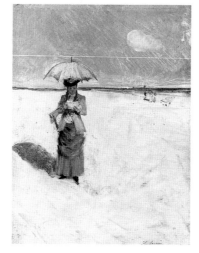

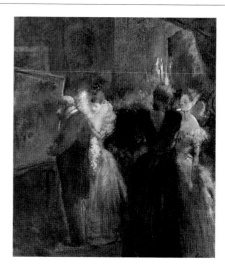

**Forain, Jean-Louis**
French, 1852-1931

*A Girl on a Yacht*
Oil on panel
18⅛ x 14¼ (46 x 35.9)
Number 882

**Forain, Jean-Louis**
French, 1852-1931

*Promenade on the Beach,* c. 1880
Oil on panel
8¹¹⁄₁₆ x 6¼ (22.1 x 15.8)
Signed lower right: jl forain
Number 736

**Forain, Jean-Louis**
French, 1852-1931

*Reception at an Exhibition*
Oil on canvas
24 x 19¹³⁄₁₆ (61 x 50.3)
Signed lower right: forain
Number 737

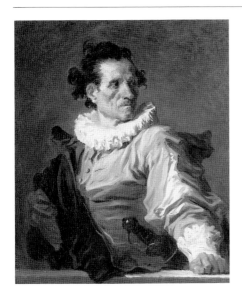

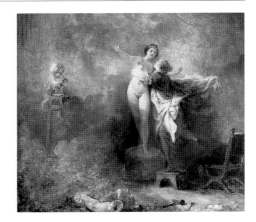

**Fragonard, Jean-Honoré**
French, 1732-1806

*The Warrior*, c. 1769
Oil on canvas
32$\frac{1}{16}$ x 25$\frac{3}{8}$ (81.5 x 64.5)
Number 1964.8

**Circle of
Fragonard, Jean-Honoré**
French, 1732-1806

*Pygmalion and Galatea*
Oil on canvas
14$\frac{9}{16}$ x 16$\frac{13}{16}$ (37 x 42.7)
Number 739

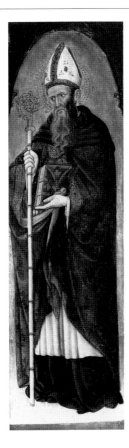

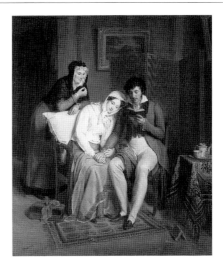

**Attributed to
Franceschi, Francesco dei**
Italian (Venetian), active 1445-1456

*Standing Bishop Saint*
Tempera with some oil on panel
42$\frac{5}{16}$ x 12$\frac{13}{16}$ (107.5 x 32.5)
Gift of the Executors of Governor
Lehman's Estate and the Edith and
Herbert Lehman Foundation
Number 1968.296

**Franquelin, Jean-Augustin**
French, 1798-1839

*La lecture à la convalescente*
(Reading to the Convalescent)
Oil on canvas
24$\frac{1}{8}$ x 19$\frac{13}{16}$ (61.3 x 50.4)
Signed lower left: Franquelin
Number 740

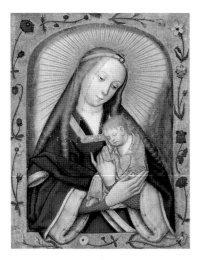

**French School**
15th Century

*Virgin and Child*
Animal glue or gum arabic medium
on linen
12⅞ x 10³⁄₁₆ (32.7 x 25.9)
Number 937

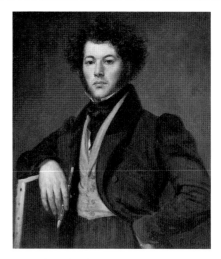

**French School**
19th Century

*An Artist,* c. 1820
Oil on canvas
32 x 25⅝ (81.3 x 65)
Falsely signed lower right:
Th. Géricault
Number 50

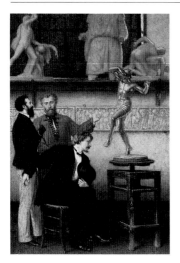

**French School**
19th Century

*Artist in His Studio,* 1877
Oil on panel
16⁵⁄₁₆ x 10¹¹⁄₁₆ (41.5 x 27.2)
Inscribed lower right: [ankh]/1877
Number 883

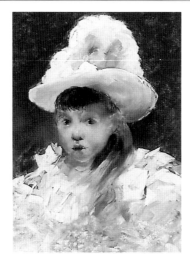

**French School**
19th Century

*Child*
Oil on panel
12¹³⁄₁₆ x 9¼ (32.5 x 23.5)
Number 819

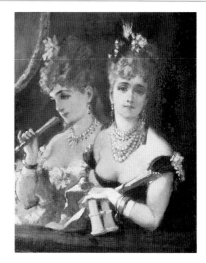

**French School**
19th Century

*Cocottes: Second Empire*
Oil on panel
6⁹⁄₁₆ x 4¹³⁄₁₆ (16.7 x 12.3)
Inscribed lower right: Paris [?]
Number 881

**French School**
19th Century

*The Hecklers*
Oil on canvas
4¼ x 5¾ (10.8 x 14.6)
Number 817

**French School**
19th Century

*Woman Seated at a Dressing Table*
Oil on panel
8⁵⁄₁₆ x 6⅝ (21.2 x 16.9)
Falsely signed lower left: G. Courbet.
Number 530

**Friant, Emile**
French, 1863-1932

*Madame Seymour,* 1889
Oil on panel
11³⁄₁₆ x 7⅜ (28.5 x 18.7)
Signed and dated upper right:
E. Friant·/89
Number 741

**Fromentin, Eugène**
French, 1820-1876

*Arabs Watering Their Horses,* 1872
Oil on panel
23½ x 28⅝ (59.6 x 72.7)
Signed and dated lower right:
- Eug.-Fromentin.-72-
Number 744

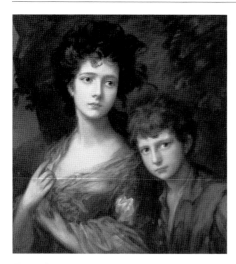

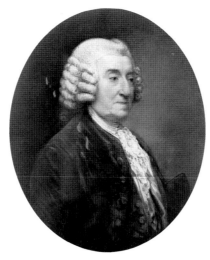

**Gainsborough, Thomas**
British, 1727-1788

*Miss Linley and Her Brother*, c. 1768
Oil on canvas
27½ x 24½ (69.8 x 62.3)
Number 955

**Gainsborough, Thomas**
British, 1727-1788

*Viscount Hampden*, c. 1780
Oil on canvas
28¼ x 22¾ (71.8 x 57.7)
Number 35

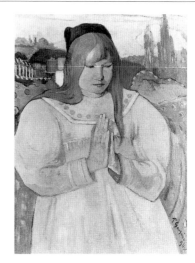

**Garcia y Ramos, José**
Spanish, 1852-1912

*Inside the Bull Ring*
Oil on panel
11³⁄₁₆ x 7 (28.5 x 17.8)
Inscribed lower right:
Garcia y Ramos./Sevilla
Number 837

**Garcia y Ramos, José**
Spanish, 1852-1912

*Outside the Bull Ring*
Oil on panel
11³⁄₁₆ x 7 (28.5 x 17.8)
Inscribed lower left:
Garcia y Ramos/Sevilla
Number 838

**Gauguin, Paul**
French, 1848-1903

*Young Christian Girl*, 1894
Oil on canvas
25¹¹⁄₁₆ x 18⅜ (65.2 x 46.7)
Signed and dated lower right:
P. Gauguin 94
Purchased in honor of Harding F.
Bancroft, Institute Trustee 1970-87;
President 1977-87
Number 1986.22

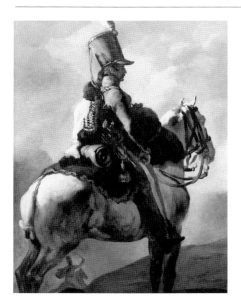

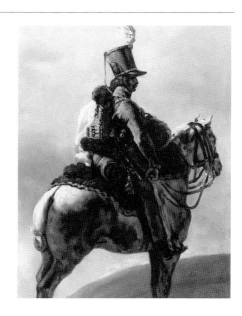

**Géricault, Théodore**
French, 1791-1824

*Trumpeter of the Hussars on Horseback,* c. 1815-20
Oil on canvas
Original dimensions 28⁵⁄₁₆ x 22³⁄₁₆ (72 x 57.2); with posthumous additions 37¹³⁄₁₆ x 28³⁄₈ (96.1 x 72.1)
Number 959

**Géricault, Théodore**
French, 1791-1824

*Study for "Trumpeter of the Hussars on Horseback,"* c. 1815-20
Oil on canvas
12⁵⁄₈ x 9⁷⁄₁₆ (32.2 x 23.9)
Number 745

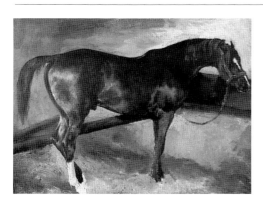

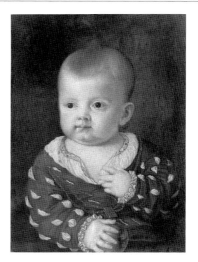

**School of Géricault, Théodore**
French, 1791-1824

*Dervish in His Stall*
Oil on paper mounted on canvas
10¹⁄₁₆ x 13³⁄₈ (25.6 x 34)
Number 746

**German School**
16th Century

*An Infant Holding an Apple*
Oil on panel
16½ x 12¼ (42 x 31.2)
Number 945

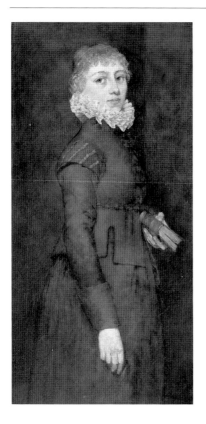

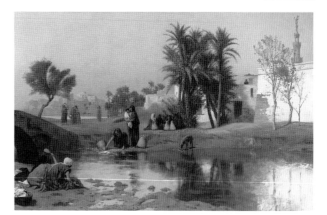

**German School**
19th Century

*Girl with a Book*
Oil on canvas
31⅝ x 15¹⁵⁄₁₆ (80.4 x 40.5)
Number 729

**Gérôme, Jean-Léon**
French, 1824-1904

*Fellah Women Drawing Water*
Oil on canvas
26½ x 39½ (67.4 x 100.3)
Signed center right: J. L. GEROME.
Number 52

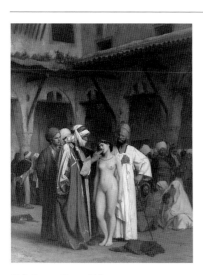

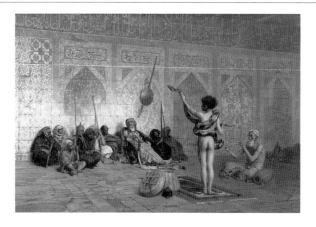

**Gérôme, Jean-Léon**
French, 1824-1904

*The Slave Market*, c. 1867
Oil on canvas
33³⁄₁₆ x 24¹³⁄₁₆ (84.3 x 63)
Signed lower right: J. L. GEROME.
Number 53

**Gérôme, Jean-Léon**
French, 1824-1904

*The Snake Charmer*, c. 1870
Oil on canvas
33 x 48¹⁄₁₆ (83.8 x 122.1)
Signed below center, left edge:
J. L GEROME.
Number 51

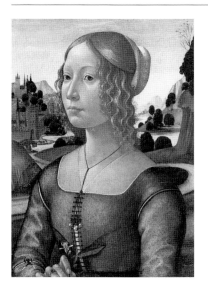

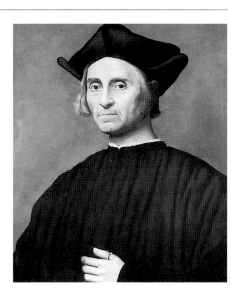

**Ghirlandaio, Domenico (Domenico di Tomaso Bigordi)**
Italian (Florentine), 1449-1494

*Portrait of a Lady,* c. 1490
Tempera and oil on panel
22⅟₁₆ x 14¹³⁄₁₆ (56.1 x 37.7)
Number 938

**Ghirlandaio, Ridolfo (Ridolfo di Domenico Bigordi)**
Italian (Florentine), 1483-1561

*Portrait of an Elderly Man*
Tempera and oil on panel
25³⁄₁₆ x 20⁵⁄₁₆ (64 x 51.6)
Number 939

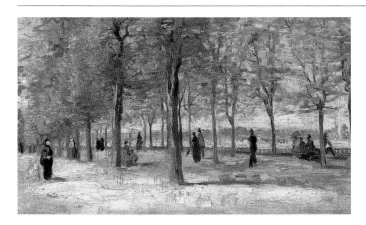

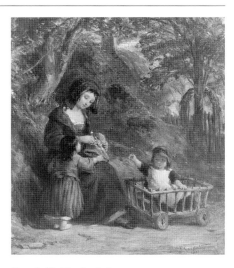

**Gogh, Vincent van**
Dutch, 1853-1890

*Terrace at the Tuileries,* 1886
Oil on canvas
10⅝ x 18⅛ (27.1 x 46.1)
Number 889

**Goodall, Frederick**
British, 1822-1904

*Mother and Children,* 1851
Oil on panel
8⅝ x 7⁹⁄₁₆ (22 x 19.2)
Signed and dated lower right:
F Goodall/1851
Number 747

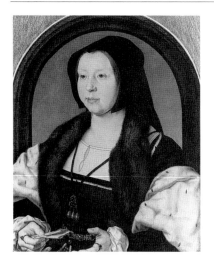

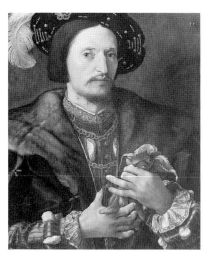

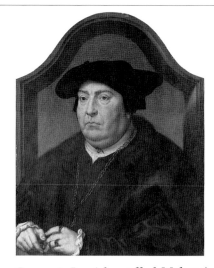

**Gossaert, Jan (also called Mabuse)**
Netherlandish, c. 1472-c. 1533

*Portrait of Anna de Berghes*, c. 1526-30
Oil on panel
22¹⁄₁₆ x 17 (56 x 43.2)
Gift of the Executors of Governor
Lehman's Estate and the Edith and
Herbert Lehman Foundation
Number 1968.297

**Gossaert, Jan (also called Mabuse)**
Netherlandish, c. 1472-c. 1533

*Portrait of a Gentleman*, c. 1530
Oil on panel transferred to canvas
25 x 20⅛ (63.5 x 51.1)
Inscribed upper right: ·35·
Gift of the Executors of Governor
Lehman's Estate and the Edith and
Herbert Lehman Foundation
Number 1968.298

**Gossaert, Jan (also called Mabuse)**
Netherlandish, c. 1472-c. 1533

*Portrait of a Man*
Oil on panel
25 x 18¹¹⁄₁₆ (63.5 x 47.5)
Number 941

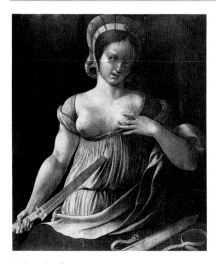

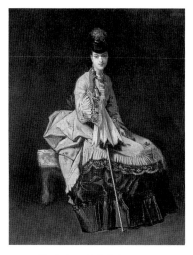

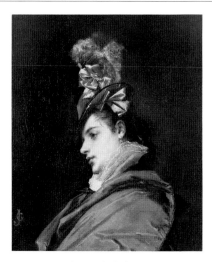

**School of
Gossaert, Jan (also called Mabuse)**
Netherlandish, c. 1472-c. 1533

*Lucretia*, 1534
Oil on panel transferred to canvas
25 x 20⅛ (63.5 x 51.1)
Inscribed lower left: ·1534·
Gift of the Executors of Governor
Lehman's Estate and the Edith and
Herbert Lehman Foundation
Number 1968.306

**Goupil, Jules Adolphe**
French, 1839-1883

*Lady Seated*
Oil on panel
12¹³⁄₁₆ x 9³⁄₁₆ (32.6 x 23.4)
Signed upper right: J Goupil
Number 748

**Goupil, Jules Adolphe**
French, 1839-1883

*Woman Wearing a Hat with a Blue
Ribbon*
Oil on panel
10⅝ x 8¼ (27 x 20.6)
Signed lower left: JG [monogram]
Number 778

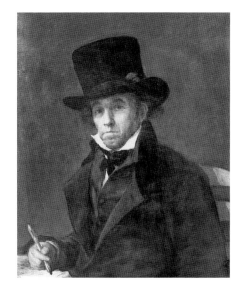

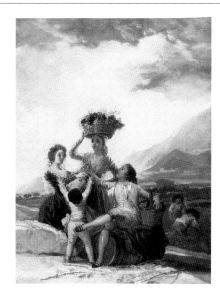

**Goya y Lucientes, Francisco José de**
Spanish, 1746-1828

*Asensio Juliå,* 1814
Oil on canvas
28¹³/₁₆ x 22¹¹/₁₆ (73.2 x 57.7)
Signed, dated, and inscribed lower
left: pʳpʳ Goya. 1814.
Number 83

**Goya y Lucientes, Francisco José de**
Spanish, 1746-1828

*Autumn*
Oil on canvas
13⅜ x 9½ (34 x 24.2)
Number 749

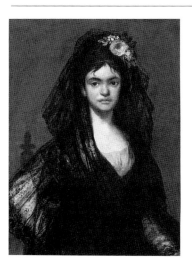

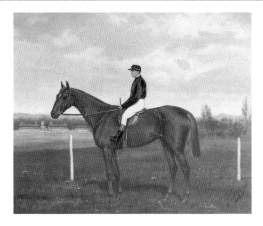

**Attributed to**
**Goya y Lucientes, Francisco José de**
Spanish, 1746-1828

*La Madrileña,* c. 1805
Oil on canvas
30⁵/₁₆ x 21½ (77 x 54.7)
Number 82

**Grant, J.**
British (?), 19th Century

*Plaisanterie,* 1886
Oil on canvas
14⅞ x 18¼ (37.8 x 46)
Signed and dated lower right:
J. Grant/86
Number 751

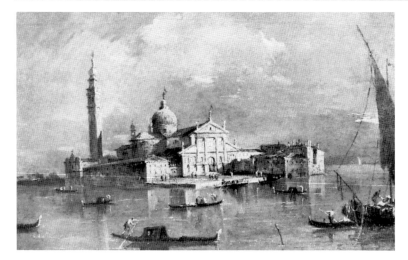

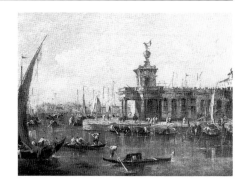

**Guardi, Francesco**
Italian (Venetian), 1712-1793

*San Giorgio Maggiore*
Oil on panel
7³⁄₁₆ x 11⁷⁄₈ (18.3 x 30.2)
Number 754

**Follower of
Guardi, Francesco**
Italian (Venetian), 1712-1793

*The Customs House, Venice*
Oil on canvas
11⅝ x 15¹⁵⁄₁₆ (29.5 x 40.3)
Number 753

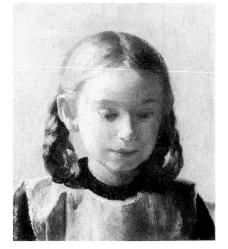

**Guillaumin, Armand**
French, 1841-1927

*Landscape*, c. 1885
Oil on canvas
28¹³⁄₁₆ x 39½ (73.2 x 100.3)
Signed lower left: Guillaumin
Gift of the Executors of Governor
Lehman's Estate and the Edith and
Herbert Lehman Foundation
Number 1969.28

**Guillaumin, Armand**
French, 1841-1927

*Snow at Pontoise*, 1873
Oil on canvas
18⅞ x 25⁹⁄₁₆ (47.9 x 65)
Signed lower right:
AGuillaumin [AG monogram]
Number 887

**Guinard, Robert Raoul André**
French, 1896-?

*Head of a Little Girl*
Oil on canvas
6⁹⁄₁₆ x 5⅝ (16.7 x 14.3)
Signed upper left: ROBERT GUINARD
Number 755

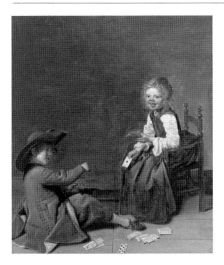

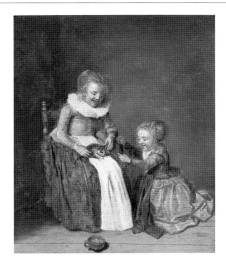

**Hals, Dirck**
Dutch, 1591-1656

*Children Playing Cards,* 1631
Oil on panel
12¹³⁄₁₆ x 10⅞ (32.6 x 27.7)
Signed and dated center:
Dirck hals/1631
Number 757

**Hals, Dirck**
Dutch, 1591-1656

*Children with a Cat*
Oil on panel
12¹³⁄₁₆ x 10⅞ (32.6 x 27.7)
Number 756

**In the style of
Hals, Frans**
Dutch, 1581/85-1666

*Coal Heaver*
Oil on canvas
24½ x 19 (62.2 x 48.3)
Inscribed lower right: H.
Number 28

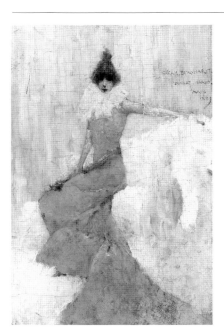

**Hardy, Dudley**
British, 1866-1922

*Sarah Bernhardt,* 1889
Oil on panel
9½ x 6½ (24.1 x 16.6)
Signed, dated, and inscribed upper
right: SARAH.BERNHARDT./DUDLEY.
HARDY./PARIS/1889.
Number 760

**Harpignies, Henri**
French, 1819-1916

*Landscape with a Church,* 1891
Oil on canvas
12¹¹⁄₁₆ x 17⅜ (32.2 x 44.2)
Signed and dated lower left:
hi harpignies 91.
Number 758

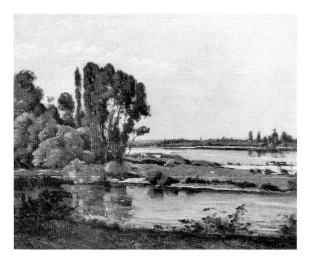

**Harpignies, Henri**
French, 1819-1916

*Landscape with a River,* 1892
Oil on canvas
15¼₆ x 18⁵₁₆ (38.3 x 46.5)
Signed and dated lower left:
hi harpignies 92.
Number 759

**Hassam, Frederick Childe**
American, 1859-1935

*Little Girl with a Pear,* c. 1889-93
Pastel on paper
16⁷₁₆ x 13⅛ (41.8 x 33.3)
Signed upper left: Childe H [illegible]
Number 761

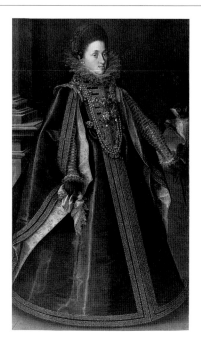

**Heilbuth, Ferdinand**
French, 1826-1889

*A Lady with Flowers*
Oil on panel
13 x 7⅞ (33 x 20.1)
Signed lower left:
FHeilbuth (FH monogram)
Number 762

**Heintz, Joseph, the Elder**
Swiss, 1564-1609

*Portrait of Konstanze von Habsburg,*
*Archduchess of Central Austria, Later*
*Queen of Poland,* 1604
Oil on canvas
72¼ x 41⅜ (183.6 x 105.2)
Gift of Julius S. Held
Number 1982.127

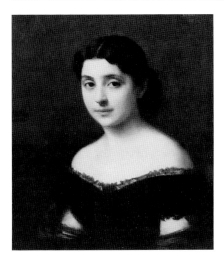

**Henner, Jean-Jacques**
French, 1829-1905

*Portrait of a Woman,* 1864
Oil on canvas
21¹⁵⁄₁₆ x 18⁵⁄₁₆ (55.7 x 46.6)
Signed and dated upper right:
HENNER/1864
Number 763

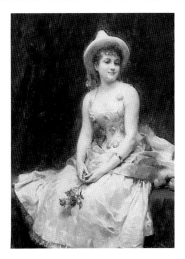

**Hernandez, Daniel**
French (born Peru), 1856-1932

*Girl with Roses*
Oil on panel
10⁹⁄₁₆ x 7⅜ (26.9 x 18.7)
Signed lower right: Daniel Hernandez
Number 765

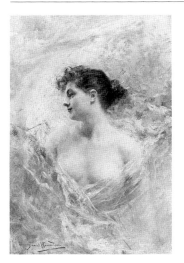

**Hernandez, Daniel**
French (born Peru), 1856-1932

*Woman*
Oil on canvas
20¹³⁄₁₆ x 13½ (52.9 x 34.3)
Signed lower left: Daniel Hernandez
Number 764

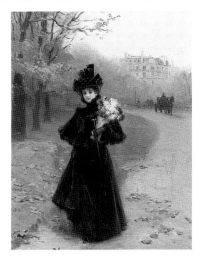

**Hernandez, Daniel**
French (born Peru), 1856-1932

*Woman with a Bouquet*
Oil on canvas
25¾ x 19¹⁵⁄₁₆ (65.4 x 50.7)
Signed lower right: Daniel Hernandez
Number 766

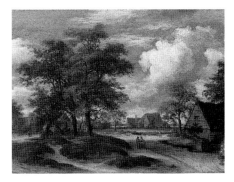

**In the style of**
**Hobbema, Meindert**
Dutch, 1638-1709

*Woodland Landscape with a Farm*
Oil on panel
23⅝ x 32¾ (60 x 83.2)
Signed lower right: Hobbema
Number 769

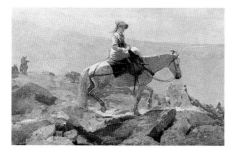
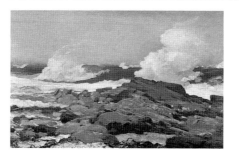
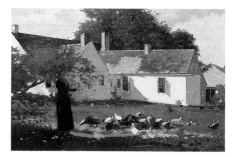

**Homer, Winslow**
American, 1836-1910

*The Bridle Path, White Mountains,*
1868
Oil on canvas
24⅛ x 38 (61.3 x 96.5)
Signed and dated lower left:
HOMER N.A./-1868-
Number 2

**Homer, Winslow**
American, 1836-1910

*Eastern Point,* 1900
Oil on canvas
30¼ x 48½ (76.8 x 123.2)
Signed and dated lower right:
Winslow Homer/Oct. 14 1900
Number 6

**Homer, Winslow**
American, 1836-1910

*Farmyard Scene,* c. 1874
Oil on canvas
12⅜ x 18⁷⁄₁₆ (31.4 x 46.8)
Signed and inscribed on stretcher:
W. Homer 51 10th St. N.Y.
Number 772

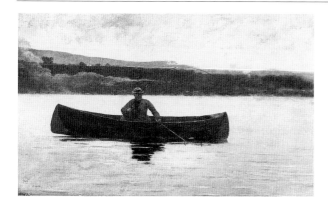
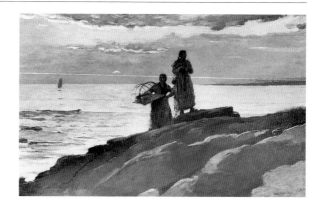

**Homer, Winslow**
American, 1836-1910

*Playing a Fish,* 1875 and early 1890s
Oil on canvas
11¹¹⁄₁₆ x 18¹⁵⁄₁₆ (29.7 x 48.1)
Signed lower left: HOMER
Number 773

**Homer, Winslow**
American, 1836-1910

*Saco Bay,* 1896
Oil on canvas
23¹³⁄₁₆ x 37¹⁵⁄₁₆ (60.5 x 96.4)
Signed and dated lower right:
HOMER 1896
Number 5

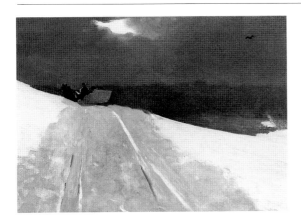

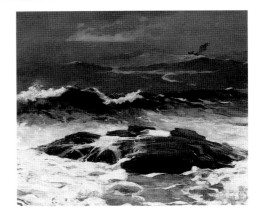

**Homer, Winslow**
American, 1836-1910

*Sleigh Ride*, c. 1890-95
Oil on canvas
14¹⁄₁₆ x 20¹⁄₁₆ (35.7 x 51)
Number 771

**Homer, Winslow**
American, 1836-1910

*Summer Squall*, 1904
Oil on canvas
24¼ x 30¼ (61.6 x 76.8)
Signed and dated lower left:
HOMER 1904
Number 8

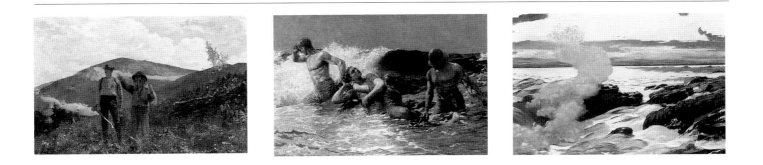

**Homer, Winslow**
American, 1836-1910

*Two Guides*, c. 1875
Oil on canvas
24¼ x 38¼ (61.6 x 97.2)
Signed and dated lower left:
Winslow Homer/187[?]
Number 3

**Homer, Winslow**
American, 1836-1910

*Undertow*, 1886
Oil on canvas
29¹³⁄₁₆ x 47⅝ (75.7 x 121)
Signed and dated lower right:
Winslow Homer/1886
Number 4

**Homer, Winslow**
American, 1836-1910

*West Point, Prout's Neck*, 1900
Oil on canvas
30¹⁄₁₆ x 48⅛ (76.4 x 122.2)
Signed and dated lower right:
HOMER 1900
Number 7

**Inness, George**
American, 1825-1894

*Home at Montclair*, 1892
Oil on canvas
30⅛ x 45 (76.5 x 114.3)
Signed and dated lower left:
G. Inness 1892
Number 10

**Inness, George**
American, 1825-1894

*Wood Gatherers: An Autumn Afternoon*, 1891
Oil on canvas
30 x 45⅛ (76.2 x 114.6)
Signed and dated lower right:
G. Inness 1891
Number 9

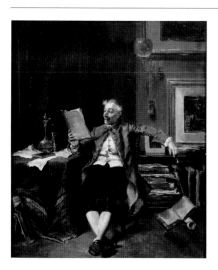

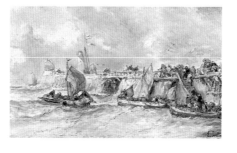

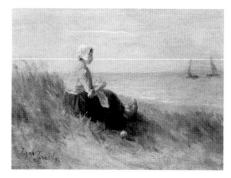

**Irving, John Beaufain**
American, 1826-1877

*An Amused Reader*, 1876
Oil on panel
10 x 7⅞ (25.4 x 20)
Signed and dated lower right:
J Beaufain Irving NA/76
Number 776

**Isabey, Eugène**
French, 1803-1886

*The Pier at Dieppe*
Oil on panel
11³⁄₁₆ x 18⅛ (28.5 x 46)
Signed lower right: E. Isabey
Gift of Mr. and Mrs. Norman Hirschl
Number 1990.62

**Israels, Jozef**
Dutch, 1824-1911

*Girl on the Shore*
Oil on panel
6 x 8³⁄₁₆ (15.2 x 20.8)
Signed lower left: Jozef/Israels
Number 777

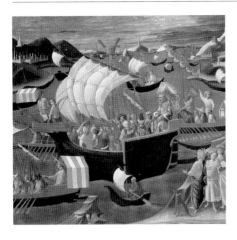

**Italian School**
Florentine, 15th Century

*Journey of the Magi* (?), c. 1440
Tempera and oil on panel
25⅝ x 27¹⁵⁄₁₆ (65.1 x 69.8)
Number 940

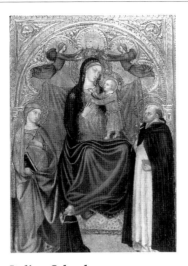

**Italian School**
Sienese, second half of the
14th Century

*The Virgin and Child with Saint
Dominic, Saint Catherine, and Donor*
Tempera on panel
15⁷⁄₁₆ x 9¹³⁄₁₆ (39.2 x 24.9)
Gift of the Executors of Governor
Lehman's Estate and the Edith and
Herbert Lehman Foundation
Number 1968.295

**Italian School**
Venetian, 17th Century

*The Bucintoro on the Grand Canal
before the Doge's Palace*
Oil on canvas
41¹⁵⁄₁₆ x 63³⁄₁₆ (106.5 x 160.5)
Bequest of Madeleine Dahlgren
Townsend
Number 1982.13

**Jacque, Charles**
French, 1813-1894

*Interior,* 1852
Oil on panel
9⁵⁄₁₆ x 7¹¹⁄₁₆ (23.7 x 19.5)
Signed and dated lower left:
-ch. Jacque -1852-
Number 781

**Jacque, Charles**
French, 1813-1894

*Landscape with Sheep*
Oil on panel
8 x 14¾ (20.3 x 37.4)
Signed lower left: ch. Jacque
Number 780

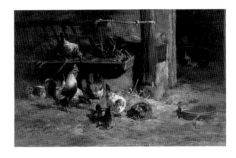

**Jacque, Charles**
French, 1813-1894

*Poultry*
Oil on canvas
8⁷⁄₁₆ x 13⁵⁄₁₆ (21.3 x 33.9)
Signed lower left: ch. Jacque
Number 779

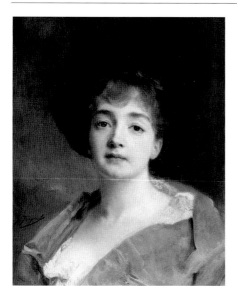

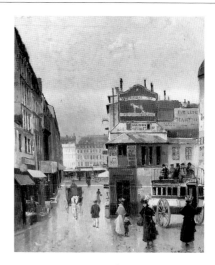

**Jacquet, Gustave Jean**
French, 1846-1909

*A Girl in Red*
Oil on canvas
13⅞ x 10⅝ (35.2 x 27)
Signed lower left: G Jacquet
Number 782

**Jardines, José María**
Spanish, 1862-?

*Rue de Siam*
Oil on panel
13¹³⁄₁₆ x 10⅝ (35.1 x 27)
Signed and inscribed lower right:
JARDINES. PARIS.
Number 783

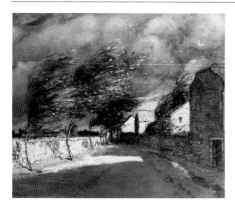

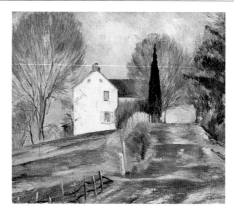

**Jeanniot, Pierre-Georges**
French, 1848-1934

*Coming Storm*, 1905
Oil on canvas
19⅝ x 24 (49.8 x 61)
Signed and dated lower left:
Jeanniot/1905
Number 784

**Johnson, Clarence**
American, 1894-1981

*At the Hill's Top—Lumberville,*
c. 1920-23
Oil on canvas
15⅛ x 18⅛ (38.4 x 46)
Signed lower right: C. Johnson
Number 1030

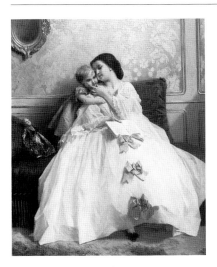

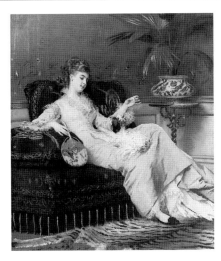

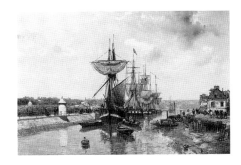

**Jonghe, Gustave de**
Belgian, 1829-1893

*Mother and Child*
Oil on panel
16 x 12⅝ (40.7 x 32.1)
Signed lower right: Gustave De
Jonghe
Number 704

**Jonghe, Gustave de**
Belgian, 1829-1893

*Woman in Yellow*
Oil on panel
23¹⁵⁄₁₆ x 19½ (60.8 x 49.5)
Signed lower left: Gustave De Jonghe
Number 705

**Jongkind, Johan Barthold**
Dutch, 1819-1891

*Frigates, Port of Harfleur*, c. 1852-53
Oil on canvas
21½ x 31¾ (54.6 x 80.6)
Signed lower right: Jongkind
Acquired in memory of Eugene W.
Goodwillie, Institute Trustee 1959-74
Number 1974.4

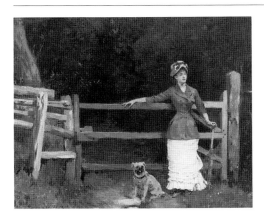

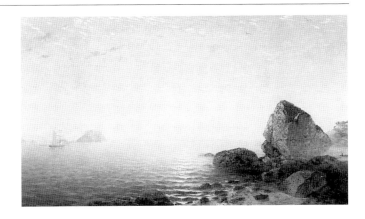

**Jourdain, Roger**
French, 1845-1918

*A Girl and Dog at the Gate*
Oil on panel
8¼ x 10⁹⁄₁₆ (21 x 26.9)
Inscribed lower left: à Anaïs
Fèvrier/Roger Jourdain
Number 785

**Kensett, John Frederick**
American, 1816-1872

*Seascape*, 1862
Oil on canvas
10⅛ x 18 (25.7 x 45.7)
Signed and dated lower right on rock:
JFK 62.
Number 1971.50

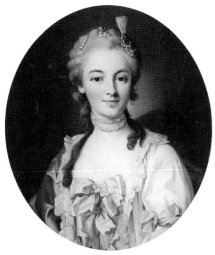

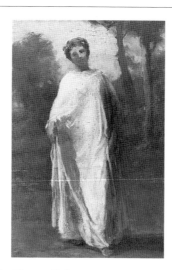

**Kraft, Per, the Elder**
Swedish, 1724-1793

*Countess Kinska,* 1765
Oil on canvas
26⁹/₁₆ x 21 (67.5 x 53.2)
Number 691

**La Farge, John**
American, 1835-1910

*Andromeda,* by 1875
Oil on academy board
9¼ x 6¹/₁₆ (23.5 x 15.4)
Gift of L. Bancel La Farge
Number 1966.9

**La Farge, John**
American, 1835-1910

*Flowers—Decorative Study,* by 1890
and 1910
Encaustic on canvas
9⅜ x 16¹⁵/₁₆ (23.8 x 43)
Gift of L. Bancel La Farge
Number 1966.10

**Lancret, Nicolas**
French, 1690-1743

*"Les deux amis,"* 1738
(The Two Friends)
Oil on copper
11¼ x 14⅜ (28.7 x 36.5)
Number 956

**Lancret, Nicolas**
French, 1690-1743

*"Nicaise,"* 1738
Oil on copper
10¹⁵/₁₆ x 14⅛ (27.9 x 35.9)
Number 957

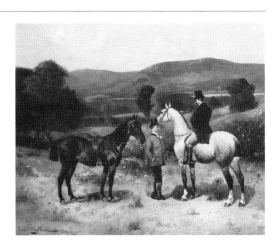

**Lawrence, Thomas**
British, 1769-1830

*The Hon. Caroline Upton,* c. 1800
Oil on canvas
27½ x 22⁹⁄₁₆ (69.9 x 57.3)
Number 958

**Leighton, Nicholas Winfield Scott**
American, 1847-1898

*Two Horses and Riders,* after 1883
Oil on canvas
10¹⁄₁₆ x 11¹⁵⁄₁₆ (25.6 x 30.3)
Signed lower left: Scott Leighton
Number 786

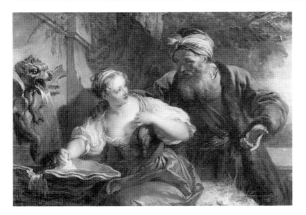

**Le Moyne, François**
French, 1688-1738

*The Amorous Proposal,* c. 1725
Oil on canvas
39 x 57 (99.1 x 144.8)
Number 1985.54

**The Le Nain Brothers**
Antoine, 1588-1648; Louis, 1593-1648;
Mathieu, 1607-1677
French

*The Young Card Players,* 1643
Oil on copper mounted on panel
11¹⁵⁄₁₆ x 15¼ (30.3 x 38.8)
Signed and dated lower left:
Le Nain [?] 1643
Number 787

 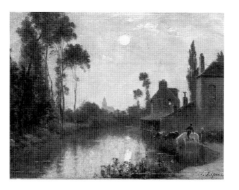 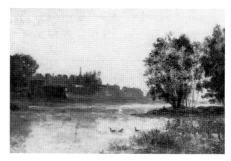

**Lépine, Stanislas**
French, 1835-1892

*Les Champs-Elysées*
Oil on canvas
8⁹⁄₁₆ x 10⅝ (21.8 x 27.1)
Signed lower right: S. Lepine
Number 788

**Lépine, Stanislas**
French, 1835-1892

*Moonlit River*
Oil on canvas
9½ x 12⅞ (24.2 x 32.7)
Signed lower right: S. Lepine
Number 789

**Lépine, Stanislas**
French, 1835-1892

*River Scene with Ducks*
Oil on canvas
9½ x 14¼ (24.2 x 36.2)
Signed lower right: S. Lepine
Number 790

  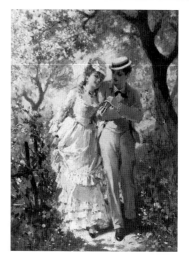

**Lépine, Stanislas**
French, 1835-1892

*Rue de l'Abreuvoir, Montmartre*
Oil on canvas
18 x 14¹³⁄₁₆ (45.8 x 37.6)
Signed lower left: S. Lepine
Number 791

**Linder, Philippe Jacques**
French, active 1857-1880

*Autumn*
Oil on canvas
12¹³⁄₁₆ x 8¹¹⁄₁₆ (32.6 x 22.1)
Signed lower left: P. Linder.
Number 793

**Linder, Philippe Jacques**
French, active 1857-1880

*Spring*
Oil on canvas
12¹³⁄₁₆ x 8¹³⁄₁₆ (32.6 x 22.4)
Signed lower left: P. Linder
Number 792

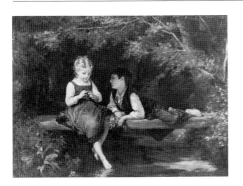

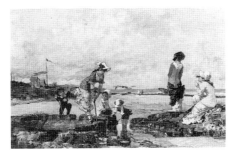

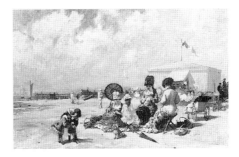

**Lobrichon, Timoléon**
French, 1831-1914

*First Love*
Oil on canvas
23½ x 31¹³⁄₁₆ (59.7 x 80.8)
Signed lower right: T. Lobrichon.
Number 794

**Loir, Luigi (Aloys François-Joseph Loir)**
French, 1845-1916

*At the Seashore*
Oil on canvas
13⁹⁄₁₆ x 20¾ (34.5 x 52.7)
Signed lower right: L Loir
Number 912

**Loir, Luigi (Aloys François-Joseph Loir)**
French, 1845-1916

*At the Seashore*
Oil on canvas
13⁹⁄₁₆ x 20¹¹⁄₁₆ (34.5 x 52.6)
Signed lower right: L Loir
Number 795

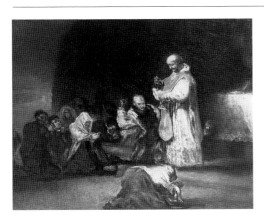

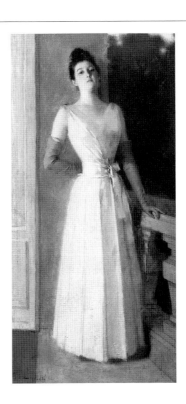

**Attributed to**
**Lucas y Padilla, Eugenio**
Spanish, 1824-1870

*A Mass*
Oil on canvas
13½ x 17¹⁄₁₆ (34.4 x 43.3)
Number 750

**Lynch, Albert**
French (born Peru), 1851-after 1912

*A Girl of 1900*
Oil on canvas
21 x 9¹⁵⁄₁₆ (53.4 x 25.3)
Signed lower left: A. Lynch
Number 796

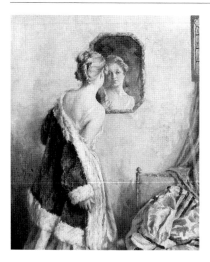

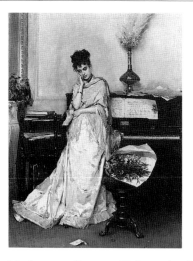

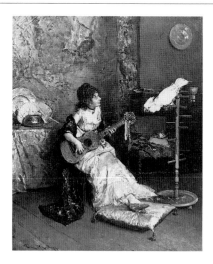

**McEwen, Walter**
American, 1860-1943

*A Girl Looking in a Mirror,* after 1890
Oil on canvas
11½ x 9⅛ (29.2 x 23.2)
Signed center left: M'EWEN
Number 806

**Madrazo y Garreta, Raimundo de**
Spanish, 1841-1920

*The Bouquet*
Oil on panel
26⅜ x 19⅟₁₆ (67 x 48.5)
Signed lower right: R. Madrazo
Number 918

**Madrazo y Garreta, Raimundo de**
Spanish, 1841-1920

*Girl with a Guitar and Parrot*
Oil on canvas
19¼ x 14¹⁵⁄₁₆ (48.9 x 38)
Signed lower left: R Madrazo
Number 800

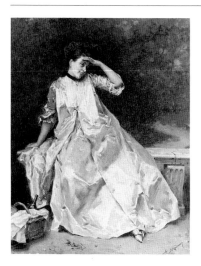

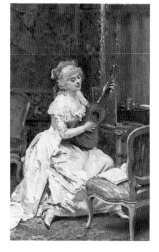

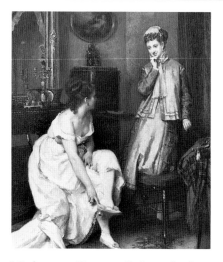

**Madrazo y Garreta, Raimundo de**
Spanish, 1841-1920

*Girl with a Picnic Basket*
Oil on panel
25⁹⁄₁₆ x 18¹³⁄₁₆ (65 x 47.8)
Signed lower right: R. Madrazo
Number 919

**Madrazo y Garreta, Raimundo de**
Spanish, 1841-1920

*Lady with a Guitar*
Oil on panel
11¹³⁄₁₆ x 6¹⁵⁄₁₆ (30.1 x 17.7)
Signed lower right: R. Madrazo
Number 799

**Madrazo y Garreta, Raimundo de**
Spanish, 1841-1920

*The Morning Visit*
Oil on canvas
36⁵⁄₁₆ x 28¾ (92.3 x 73)
Signed lower left: R. Madrazo
Number 798

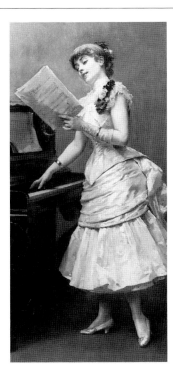

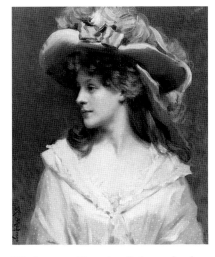

**Madrazo y Garreta, Raimundo de**
Spanish, 1841-1920

*Pierrette at the Piano*
Oil on panel
34¾ x 15¹¹⁄₁₆ (88.2 x 39.9)
Signed lower left: R. Madrazo
Number 797

**Madrazo y Garreta, Raimundo de**
Spanish, 1841-1920

*Woman in White*
Oil on canvas
28⅝ x 23⁵⁄₁₆ (72.8 x 59.3)
Signed lower left: R. Madrazo
Number 1034

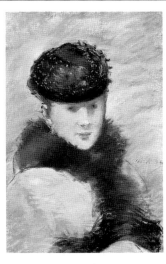

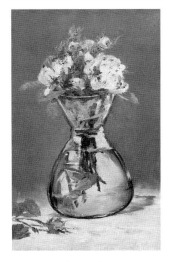

**Manet, Edouard**
French, 1832-1883

*Interior at Arcachon*, 1871
Oil on canvas
15½ x 21⅛ (39.4 x 53.7)
Signed lower right: Manet
Number 552

**Manet, Edouard**
French, 1832-1883

*Méry Laurent Wearing a Small Toque,*
c. 1882-83
Pastel on canvas
22 x 14⅛ (55.9 x 35.9)
Signed right, below center: Manet
Number 565

**Manet, Edouard**
French, 1832-1883

*Moss Roses in a Vase*, 1882
Oil on canvas
22 x 13½ (55.9 x 34.3)
Signed lower right: Manet
Number 556

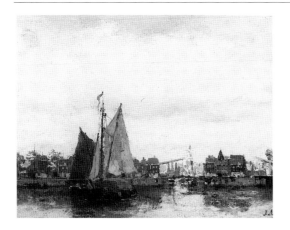

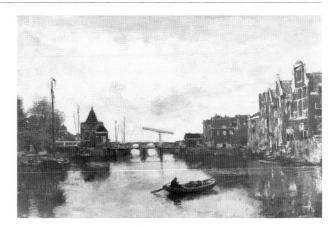

**Maris, Jacob Henricus**
Dutch, 1837-1899

*Harbor Scene*
Oil on canvas
7⁹⁄₁₆ x 10⅜ (19.3 x 26.4)
Signed lower right: J Maris
Number 802

**Maris, Jacob Henricus**
Dutch, 1837-1899

*View of a Dutch Town,* 1873
Oil on canvas
14½ x 22½ (36.9 x 57.1)
Signed and dated lower right:
J Maris [fc?] 73
Number 803

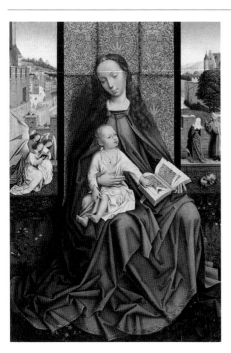

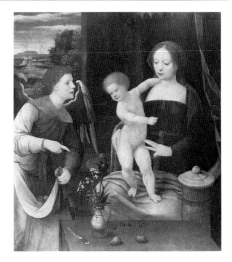

**Master of the Embroidered Foliage**
Netherlandish, 15th Century

*The Virgin and Child Enthroned*
Oil on panel
38¹¹⁄₁₆ x 25¹⁵⁄₁₆ (98.3 x 65.9)
Gift of the Executors of Governor
Lehman's Estate and the Edith and
Herbert Lehman Foundation
Number 1968.299

**Master of the Female Half-Lengths**
Netherlandish, active c. 1500-1533

*The Virgin and Child with an Angel*
Oil on panel
23¾ x 20⁵⁄₁₆ (60.3 x 51.6)
Gift of the Executors of Governor
Lehman's Estate and the Edith and
Herbert Lehman Foundation
Number 1968.302

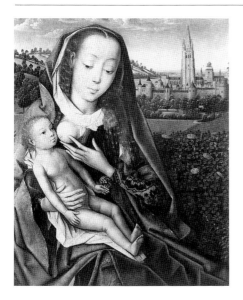

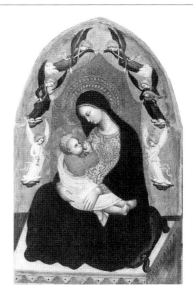

**Master of the Legend of Saint Lucy**
Netherlandish, active 1480-1490

*Virgin and Child in a Landscape*
Tempera with some oil on panel
15⅞ x 12⁹⁄₁₆ (40.4 x 32)
Number 942

**Master of the Straus Madonna**
Italian (Florentine),
active 14th-15th Century

*Virgin and Child with Musical Angels*
Tempera possibly with some oil on
panel
29½ x 18¼ (74.9 x 46.4)
Gift of the Executors of Governor
Lehman's Estate and the Edith and
Herbert Lehman Foundation
Number 1968.304

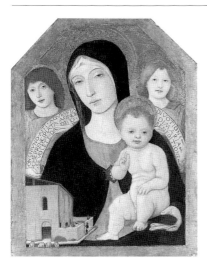

**Matteo di Giovanni**
Italian (Sienese), c. 1430-1495

*Virgin and Child with Two Angels*
Tempera on panel
23¹³⁄₁₆ x 17¹³⁄₁₆ (60.5 x 45.3)
Number 934

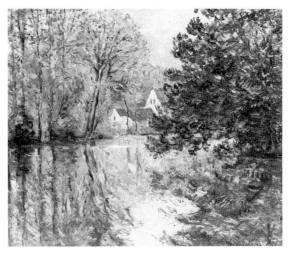

**Maufra, Maxime**
French, 1861-1918

*The Loir at Poncé,* 1918
Oil on canvas
21¼ x 25¹¹⁄₁₆ (54 x 65.2)
Signed and dated lower right:
Maufra 1918.
Number 805

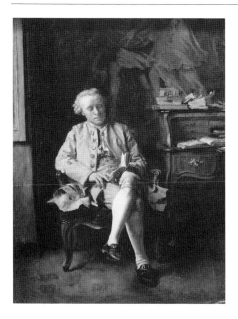

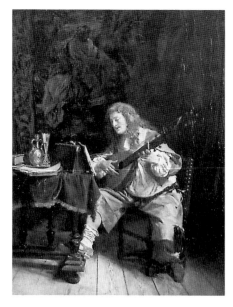

**Meissonier, Ernest**
French, 1817-1891

*Man Reading,* 1851
Oil on panel
6¾ x 5⅛ (17.2 x 13.1)
Signed and dated lower right:
EMeissonier [EM monogram] 1851
Number 812

**Meissonier, Ernest**
French, 1817-1891

*The Musician,* 1859
Oil on panel
9⁷⁄₁₆ x 6¹³⁄₁₆ (24 x 17.4)
Signed and dated lower left:
Meissonier [EM monogram] 1859
Number 810

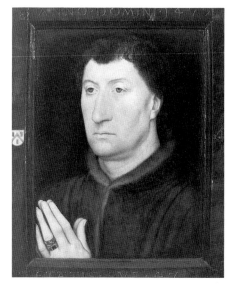

**Meissonier, Ernest**
French, 1817-1891

*Le Président, J. Pelletier,* 1867
Oil on panel
8 x 5⅝ (20.4 x 14.4)
Signed, dated, and inscribed upper
right: Le Président J. Pelletier/par son
ami E Meissonier [EM monogram]/1867
Number 811

**Memling, Hans**
Netherlandish, 1430(?)-1494

*The Canon Gilles Joye,* 1472
Tempera with some oil on panel
14¹³⁄₁₆ x 11⁷⁄₁₆ (37.6 x 29.1)
Inscribed on frame at top:
ANNO·DOMINI·1472; inscribed on
frame at bottom: ETATIS·SVE·47
Number 943

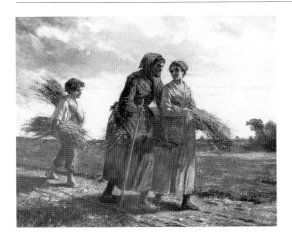

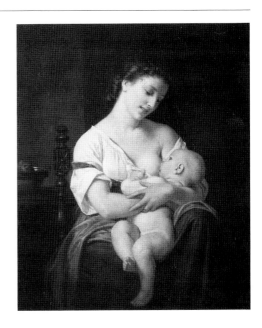

**Merle, Hugues**
French, 1823-1881

*The Gleaners*
Oil on canvas
12¾ x 16 1/16 (32.4 x 40.8)
Signed lower right: HUGUES — MERLE.
Number 809

**Merle, Hugues**
French, 1823-1881

*Mother and Child*
Oil on canvas
9⅝ x 7 9/16 (24.5 x 19.2)
Signed and dated center left:
HMerle. 186[5?] [HM monogram]
Number 807

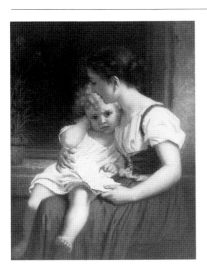

**Merle, Hugues**
French, 1823-1881

*Mother and Child*
Oil on canvas
9⅝ x 7½ (24.5 x 19.1)
Signed lower right: Hugues Merle
Number 808

**Meyer von Bremen (Johann Georg Meyer)**
German, 1813-1886

*The Secret*, 1885
Oil on canvas
15 11/16 x 11 15/16 (39.8 x 30.3)
Signed, dated, and inscribed upper
left: Meyer von Bremen/Berlin 1885
Gift of the children of
Mrs. E. Parmalee Prentice
Number 1962.149

**Millet, Jean-François**
French, 1814-1875

*The Knitting Lesson,* c. 1860
Oil on panel
16⅝ x 12⁹⁄₁₆ (41.5 x 31.9)
Signed lower right: J. F. Millet
Number 533

**Millet, Jean-François**
French, 1814-1875

*The Shepherdess: Plains of Barbizon,*
c. 1862
Oil on panel
14¹⁵⁄₁₆ x 10¾ (38 x 27.3)
Signed lower right: J. F. Millet.
Number 532

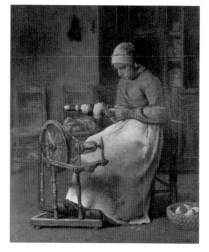

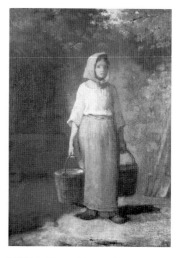

**Millet, Jean-François**
French, 1814-1875

*The Sower*
Pastel on paper
18⁹⁄₁₆ x 14¾ (47.1 x 37.5)
Signed lower right: J. F. Millet
Gift of Mr. and Mrs. Norman Hirschl
Number 1982.8

**Millet, Jean-François**
French, 1814-1875

*The Spinning Wheel,* c. 1855
Oil on panel
15⅜ x 11⅝ (39 x 29.5)
Signed lower right: J. F. Millet.
Number 531

**Millet, Jean-François**
French, 1814-1875

*The Water Carrier*
Oil on panel
10¼ x 7³⁄₁₆ (26.1 x 18.3)
Signed lower right: J. F. Millet
Number 551

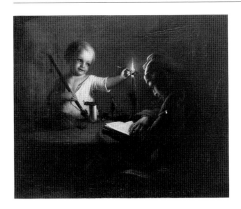 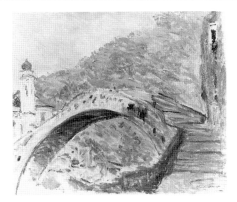 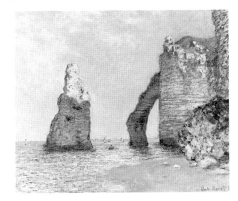

**Minor, Ferdinand**
German, 1814-1883

*The Smoker*
Oil on canvas
30⅝ x 37⁵⁄₁₆ (77.8 x 94.8)
Signed lower right: Minor.p.
Gift of the children of
Mrs. E. Parmalee Prentice
Number 1962.150

**Monet, Claude**
French, 1840-1926

*Bridge at Dolceacqua,* 1884
Oil on canvas
25⅝ x 32⅛ (65 x 81.6)
Stamped lower right: Claude Monet
Gift of Richard and Edna Salomon
Number 1985.11

**Monet, Claude**
French, 1840-1926

*The Cliffs at Etretat,* 1885
Oil on canvas
25⁹⁄₁₆ x 31¹⁵⁄₁₆ (64.9 x 81.1)
Signed and dated lower right:
Claude Monet 85
Number 528

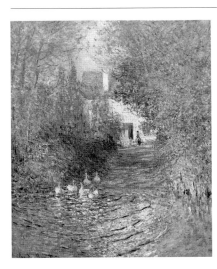 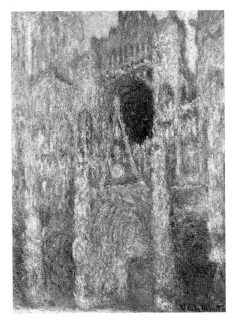

**Monet, Claude**
French, 1840-1926

*The Duck Pond,* 1874
Oil on canvas
28⅞ x 23¹¹⁄₁₆ (73.3 x 60.2)
Signed and dated lower left:
Claude Monet 74
Number 529

**Monet, Claude**
French, 1840-1926

*Rouen Cathedral, The Façade in
Sunlight,* 1894
Oil on canvas
41¹³⁄₁₆ x 29 (106.3 x 73.7)
Signed and dated lower right:
Claude Monet 94
Purchased in memory of
Anne Strang Baxter
Number 1967.1

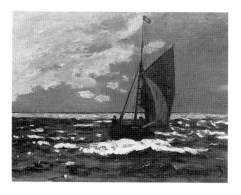

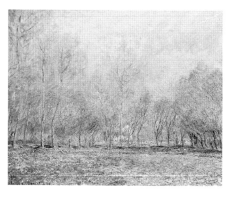

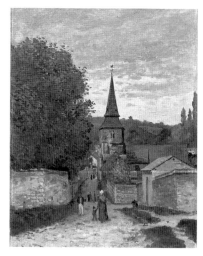

**Monet, Claude**
French, 1840-1926

*Seascape: Storm*, 1866
Oil on canvas
19³⁄₁₆ x 25½ (48.7 x 64.7)
Signed lower right: Claude Monet
Number 561

**Monet, Claude**
French, 1840-1926

*Spring in Giverny*, 1890
Oil on canvas
25¹¹⁄₁₆ x 32 (65.2 x 81.3)
Signed and dated lower left:
Claude Monet 90
Number 616

**Monet, Claude**
French, 1840-1926

*Street in Sainte-Adresse*, 1868-70
Oil on canvas
31⅜ x 23¼ (79.7 x 59)
Signed lower left: Claude Monet
Number 523

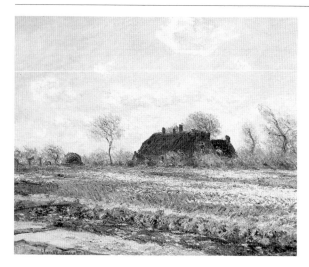

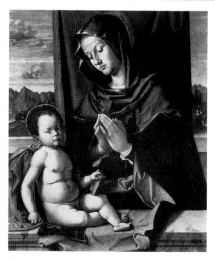

**Monet, Claude**
French, 1840-1926

*Tulip Fields at Sassenheim, near
Leiden*, 1886
Oil on canvas
23½ x 28¹³⁄₁₆ (59.7 x 73.2)
Signed and dated lower left:
Claude Monet 86
Number 615

**Montagna, Bartolomeo**
Italian (Venetian), c. 1450-1523

*Virgin Adoring the Child*
Tempera and oil on panel
30½ x 24⅝ (77.5 x 62.5)
Signed lower right: ·B· ·M· P·
Number 944

**Monticelli, Adolphe-Joseph**
French, 1824-1886

*Flowers in a Blue Bowl*
Oil on panel
24⅝ x 18¹³⁄₁₆ (62.5 x 47.8)
Signed lower right: Monticelli/
Number 911

**Moore, Albert Joseph**
British, 1841-1893

*Reclining Model,* c. 1873
Oil on canvas
11¾ x 18¹³⁄₁₆ (29.8 x 47.8)
Signed upper edge left:
[artist's insignia]
Number 818

**Moreau, Adrien**
French, 1843-1906

*Contemplation,* 1873
Oil on canvas
25¾ x 15¹⁄₁₆ (65.4 x 38.3)
Signed and dated lower right:
ADRIEN.MOREAU/73
Number 1031

**Moreau, Adrien**
French, 1843-1906

*The Proposal,* 1878
Oil on canvas
23⅝ x 32⅛ (60.1 x 81.6)
Signed and dated lower right:
ADRIEN-MOREAU.1878.
Gift of the children of
Mrs. E. Parmalee Prentice
Number 1962.151

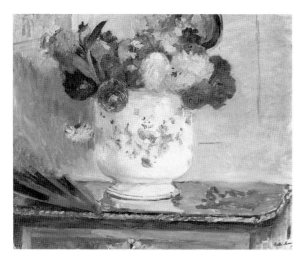

**Morisot, Berthe**
French, 1841-1895

*Dahlias,* c. 1876
Oil on canvas
18⅛ x 22 (46 x 55.9)
Signed lower right: Berthe Morisot
Number 1974.28

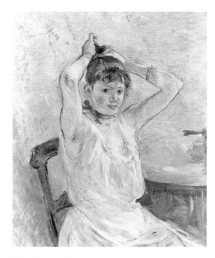

**Morisot, Berthe**
French, 1841-1895

*A Girl Arranging Her Hair,* 1885-86
Oil on canvas
35⅞ x 28⅞₁₆ (91.1 x 72.3)
Signed lower right:
Berthe Morisot/Berthe Morisot
Number 926

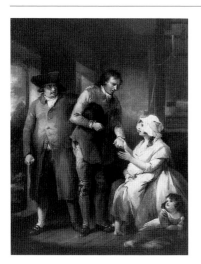

**Morland, George**
British, 1763-1804

*The Merciless Bailiff*
Oil on canvas
18½ x 14³⁄₁₆ (47.1 x 36.1)
Signed left, below center:
G. MorLand
Number 820

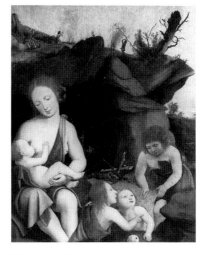

**Mostaert, Jan**
Netherlandish, c. 1472/3-c. 1555/6

*Eve and Four Children,* c. 1520
Tempera possibly with some oil on
panel
14½ x 11⅛ (36.8 x 28.3)
Number 946

**Munnings, Alfred J.**
British, 1878-1959

*Solario,* 1926
Oil on board
16¹⁵⁄₁₆ x 20 (43 x 50.9)
Signed, dated, and inscribed lower
right: Colour Study of/"Solario"/
Newmarket July 1926/A.j. Munnings
Number 925

**Murillo, Bartolomé Esteban**
Spanish, 1617-1682

*Fray Julian of Alcala's Vision of the*
*Ascension of the Soul of*
*King Philip II of Spain,* 1645-46
Oil on canvas
66¹⁵⁄₁₆ x 73⅝ (170 x 187)
Number 1968.19

**Navez, François Joseph**
Belgian, 1787-1869

*Musical Group,* 1821
Oil on canvas
45⅞ x 54½ (116.5 x 138.4)
Signed, dated, and inscribed lower
left: . . NAVEZ/ROMA 1821.
Number 1976.1

**Netherlandish School**
Bruges, 16th Century

*Annunciation,* c. 1520
Tempera on panel
18¹⁄₁₆ x 14⅛ (45.9 x 35.9)
Number 935

**Neuville, Alphonse de**
**(Alphonse Deneuville)**
French, 1835-1885

*Champigny,* 1870
Oil on panel
9¼ x 12½ (23.6 x 31.8)
Inscribed upper right: Champigny 2
Décᵇʳᵉ 1870; signed and dated lower
left: A de Neuville 1870
Number 706

**Neuville, Alphonse de**
**(Alphonse Deneuville)**
French, 1835-1885

*A Grenadier of the 3rd,* 1876
Oil on panel
13⁷⁄₁₆ x 9⁷⁄₁₆ (34.1 x 24)
Signed and dated lower left:
A de Neuville/1876
Number 707

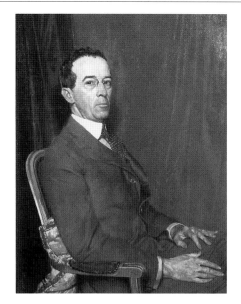

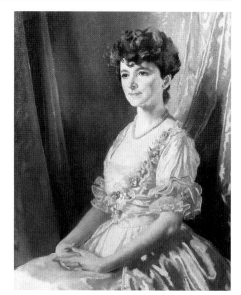

**Orpen, William**
British, 1878-1931

*Portrait of Robert Sterling Clark,*
1921-22
Oil on canvas
40⅛ x 29½ (102 x 75)
Signed upper left: ORPEN
Number 824

**Orpen, William**
British, 1878-1931

*Portrait of Francine J. M. Clark,*
1921-22
Oil on canvas
40⅛ x 30⅛ (102 x 76.5)
Signed upper left: ORPEN
Number 823

**Penne, Olivier de**
French, 1831-1897

*Hunting Hounds*
Oil on panel
10⅝ x 8⅜ (27 x 21.3)
Signed lower right: Ol. de Penne.
Number 913

**Penne, Olivier de**
French, 1831-1897

*Setters and Rabbits*
Oil on panel
7⅜ x 9⅝ (18.8 x 24.5)
Signed lower left: Ol. de Penne
Number 708

**Penne, Olivier de**
French, 1831-1897

*Two Pointers*
Oil on canvas
18⁵⁄₁₆ x 24 (46.6 x 61)
Signed lower right: Ol. de Penne
Number 709

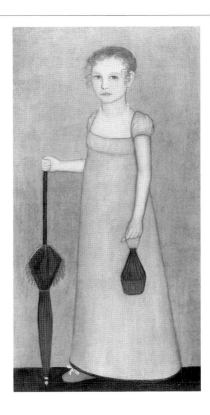

**Perugino (Pietro di Cristoforo Vannucci)**
Italian (Umbrian), c. 1450-1523

*Sepulcrum Christi*
Oil possibly with some tempera on panel, transferred to fabric on panel
36⁷⁄₁₆ x 28¼ (92.6 x 71.8)
Inscribed lower left: SEPVLCRVM·CHRIS; inscribed lower right: ·PETRVS·PERVSI/NVS·PINXIT.
Number 947

**Phillips, Ammi**
American, 1788-1865

*Portrait of Harriet Campbell,* c. 1815
Oil on canvas
48½ x 25 (123.2 x 63.5)
Gift of Oliver Eldridge in memory of Sarah Fairchild Anderson, teacher of art, North Adams Public Schools, daughter of Harriet Campbell
Number 1991.8

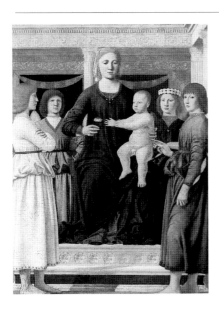

**Piero della Francesca**
Italian (Tuscan), c. 1420-1492

*Virgin and Child Enthroned with Four Angels,* c. 1460-70
Oil possibly with some tempera on panel, transferred to fabric on panel
42⁷⁄₁₆ x 30⅞ (107.8 x 78.4)
Number 948

**Pissarro, Camille**
French, 1830-1903

*The Artist's Palette with a Landscape,* c. 1878
Oil on panel
9½ x 13⅝ (24.1 x 34.6)
Signed lower left: C Pissarro
Number 827

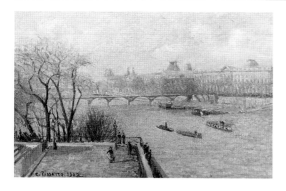

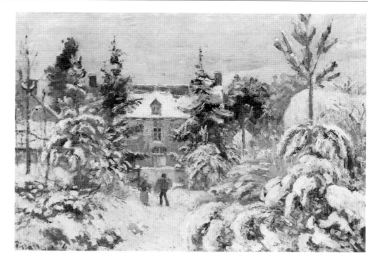

**Pissarro, Camille**
French, 1830-1903

*The Louvre from the Pont Neuf,* 1902
Oil on canvas
23¾ x 36⁵⁄₁₆ (60.4 x 92.3)
Signed and dated lower left:
C. Pissarro. 1902
Number 558

**Pissarro, Camille**
French, 1830-1903

*Piette's House at Montfoucault,* 1874
Oil on canvas
18¹⁄₁₆ x 26⅝ (45.9 x 68.3)
Signed and dated lower left:
C. Pissarro. 1874
Number 826

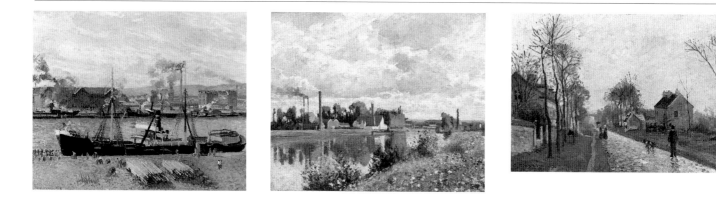

**Pissarro, Camille**
French, 1830-1903

*Port of Rouen: Unloading Wood,* 1898
Oil on canvas
28¾ x 36¼ (73 x 92.1)
Signed and dated lower left:
C. Pissarro. 98
Purchased in honor of John E. Sawyer,
Institute Trustee 1962-89
Number 1989.3

**Pissarro, Camille**
French, 1830-1903

*The River Oise near Pontoise,* 1873
Oil on canvas
17¹³⁄₁₆ x 21⅝ (45.3 x 55)
Signed and dated lower right:
C. Pissarro. 1873
Number 554

**Pissarro, Camille**
French, 1830-1903

*The Road: Rain Effect,* 1870
Oil on canvas
15¹³⁄₁₆ x 22³⁄₁₆ (40.2 x 56.3)
Signed and dated lower left:
C. Pissarro 1870
Number 825

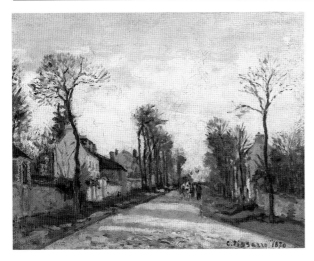

**Pissarro, Camille**
French, 1830-1903

*The Road to Versailles at
Louveciennes,* 1870
Oil on canvas
12⅞ x 16³⁄₁₆ (32.8 x 41.1)
Signed and dated lower right:
C. Pissarro. 1870
Number 828

**Pissarro, Camille**
French, 1830-1903

*Saint-Charles, Eragny,* 1891
Oil on canvas
31¹³⁄₁₆ x 25⁹⁄₁₆ (80.9 x 64.9)
Signed and dated lower left:
C. Pissarro. 1891.
Number 524

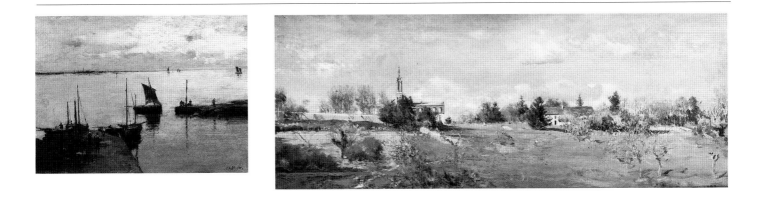

**Platt, Charles Adams**
American, 1861-1933

*The Quay, Larmor,* 1884-85
Oil on canvas
10⁵⁄₁₆ x 14½ (26.2 x 36.8)
Signed lower right: .C. A. Platt.
Number 829

**Pokitonow, Ivan**
Russian, 1851-?

*Landscape,* 1887
Oil on panel
4¼ x 10⁷⁄₁₆ (10.9 x 26.6)
Signed and dated lower right:
I Pokitonow. 1887
Number 830

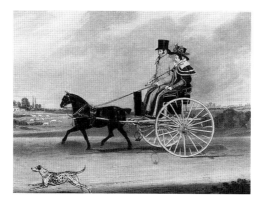

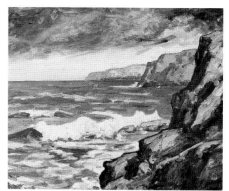

**Pollard, James**
British, 1792-1867

*Tom Thumb: Peter Brown and His Wife,* 1828
Oil on canvas
15¹/₁₆ x 20 (38.2 x 50.9)
Signed, dated, and inscribed lower center: J Pollard Holloway 1828
Number 923

**Pontiac**
American, 20th Century (?)

*Seascape*
Oil on canvas
20 x 24 (50.8 x 61)
Signed lower left: Pontiac.
Number 831

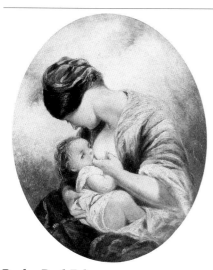

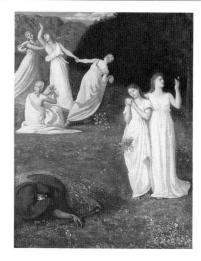

**Poole, Paul Falconer**
British, 1807-1879

*Mother and Child*
Oil on panel
10 x 8⁵/₁₆ (25.5 x 21.2)
Number 832

**Provost, Jan, the Younger**
Netherlandish, c. 1465-1529

*The Lamentation,* c. 1490
Oil on panel
16⁵/₈ x 12¹⁵/₁₆ (42.3 x 32.9)
Number 949

**Puvis de Chavannes, Pierre**
French, 1824-1898

*Death and the Maidens,* 1872
Oil on canvas
57½ x 46⅛ (146.1 x 117.2)
Signed and dated lower right:
P. Puvis de Chavannes/1872
Number 54

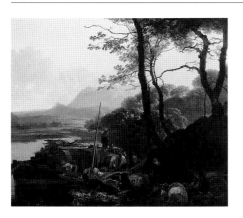 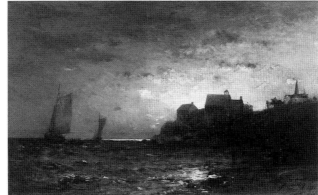

**Pynacker, Adam**
Dutch, c. 1620-1673

*The Ferryboat*, c. 1657
Oil on canvas
25½ x 29¾ (64.8 x 75.7)
Signed lower right: A Pijnacker
Number 1990.6

**Quartley, Arthur**
American, 1839-1886

*Marine*, 1881
Oil on canvas
13⅜ x 21⁷⁄₁₆ (34 x 54.5)
Signed and dated lower right:
AQuartley [AQ monogram] 1881
Number 914

**Raeburn, Henry**
British, 1756-1823

*Colin Campbell of Park*, c. 1822-23
Oil on canvas
30 x 25 (76.2 x 63.5)
Gift of Denison B. Hull
Number 1974.10

**Raeburn, Henry**
British, 1756-1823

*Miss Elizabeth Haig*, c. 1796-1800
Oil on canvas
50 x 40 (127 x 101.6)
Gift of Asbjorn R. Lunde
Number 1979.52

**Redouté, Pierre Joseph**
French, 1759-1840

*Flowers*, 1820
Oil on canvas
16¹⁄₁₆ x 13 (40.8 x 33.1)
Signed and dated lower right:
P. J. Redouté f^{it} 1820.
Number 839

**School of**
**Rijn, Rembrandt Harmensz. van**
Dutch, 1606-1669

*Crucifixion*
Oil on panel
12¹⁵⁄₁₆ x 11¼ (32.9 x 28.6)
Falsely signed and dated lower center
on cross: REMbrandt 1657
Number 840

**School of**
**Rijn, Rembrandt Harmensz. van**
Dutch, 1606-1669

*A Man Reading*
Oil on canvas
29³⁄₁₆ x 22⅛ (74.1 x 56.2)
Falsely signed and dated right, below
center: Rembrandt·f:/164[8?].
Number 841

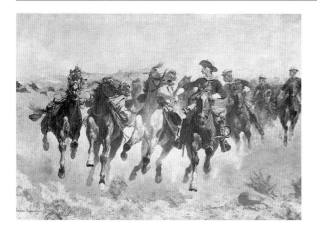

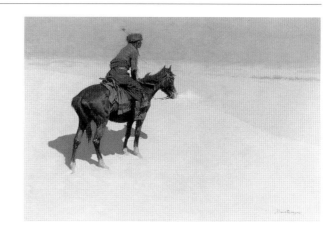

**Remington, Frederic**
American, 1861-1909

*Dismounted: The Fourth Trooper*
*Moving the Led Horses,* 1890
Oil on canvas
34¹⁄₁₆ x 48¹⁵⁄₁₆ (86.5 x 124.3)
Signed and dated lower left:
FREDERIC REMINGTON./1890
Number 11

**Remington, Frederic**
American, 1861-1909

*The Scout: Friends or Foes,* c. 1900-05
Oil on canvas
27 x 40 (68.6 x 101.6)
Signed lower right:
Frederic Remington
Number 12

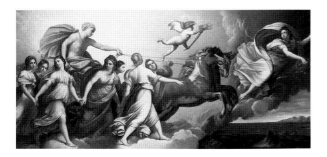

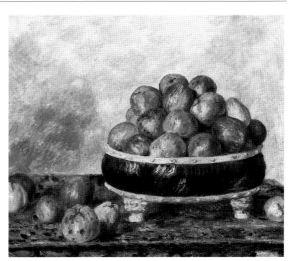

**After**
**Reni, Guido**
Italian (Bolognese), 1575-1642

*Chariot of Aurora*
Oil on canvas
21⅝ x 44⅞ (54.9 x 114)
Number 1033

**Renoir, Pierre-Auguste**
French, 1841-1919

*Apples in a Dish,* 1883
Oil on canvas
21³⁄₁₆ x 25⁹⁄₁₆ (53.9 x 65)
Signed and dated lower left:
Renoir. 83.
Number 599

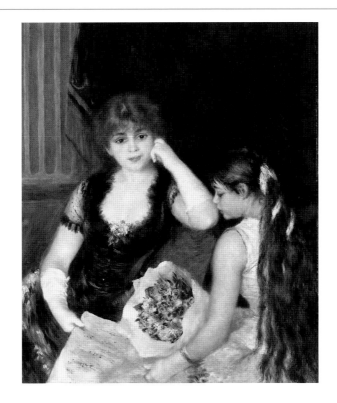

**Renoir, Pierre-Auguste**
French, 1841-1919

*At the Concert,* 1880
Oil on canvas
39¹⁄₁₆ x 31¾ (99.2 x 80.6)
Signed and dated upper left: Renoir.
80.; signed center left: Renoir.
Number 594

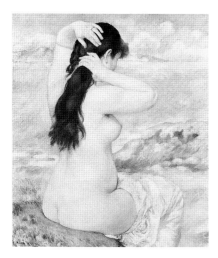

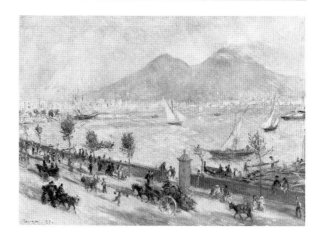

**Renoir, Pierre-Auguste**
French, 1841-1919

*Bather Arranging Her Hair,* 1885
Oil on canvas
36³⁄₁₆ x 28¾ (91.9 x 73)
Signed and dated lower left:
Renoir. 85.
Number 589

**Renoir, Pierre-Auguste**
French, 1841-1919

*The Bay of Naples with Vesuvius in the Background,* 1881
Oil on canvas
22¹³⁄₁₆ x 31¹³⁄₁₆ (57.9 x 80.8)
Signed and dated lower left:
Renoir. 81.
Number 587

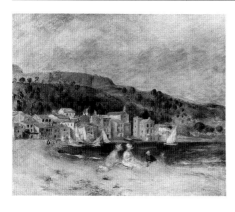

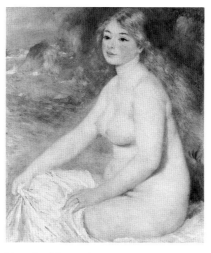

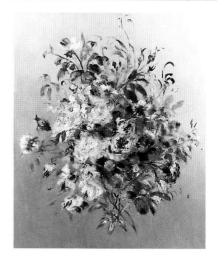

**Renoir, Pierre-Auguste**
French, 1841-1919

*The Beach at Le Lavandou, French Riviera,* 1894
Oil on canvas
18⅛ x 21¹⁵⁄₁₆ (46 x 55.8)
Signed lower right: Renoir.
Gift of Halleck and Sarah Barney Lefferts
Number 1964.9

**Renoir, Pierre-Auguste**
French, 1841-1919

*Blonde Bather,* 1881
Oil on canvas
32³⁄₁₆ x 25⅞ (81.8 x 65.7)
Signed, dated, and inscribed upper right: à Monsieur H. Vever/Renoir 81 [partially overpainted]/Renoir.81.
Number 609

**Renoir, Pierre-Auguste**
French, 1841-1919

*A Bouquet of Roses,* 1879
Oil on panel
32¹¹⁄₁₆ x 25¼ (83.1 x 63.8)
Signed and dated lower right:
Renoir .79.
Number 592

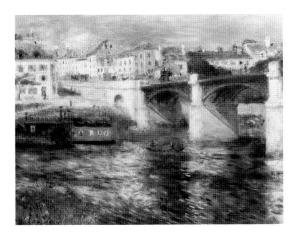

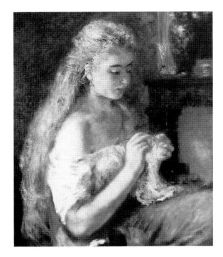

**Renoir, Pierre-Auguste**
French, 1841-1919

*Bridge at Chatou*, c. 1875
Oil on canvas
20¹⁄₁₆ x 25¹¹⁄₁₆ (51 x 65.2)
Signed lower right: Renoir.
Number 591

**Renoir, Pierre-Auguste**
French, 1841-1919

*A Girl Crocheting*, c. 1875
Oil on canvas
28⁷⁄₈ x 23¹³⁄₁₆ (73.3 x 60.5)
Signed lower right: Renoir.
Number 603

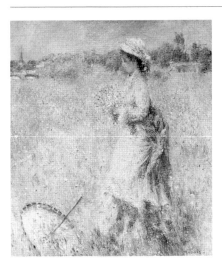

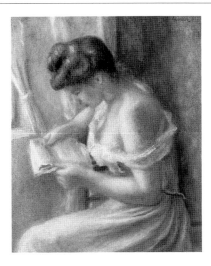

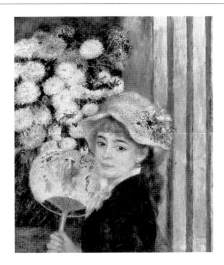

**Renoir, Pierre-Auguste**
French, 1841-1919

*A Girl Gathering Flowers*, c. 1872
Oil on canvas
25¾ x 21⁷⁄₁₆ (65.5 x 54.4)
Signed lower right: Renoir.
Number 907

**Renoir, Pierre-Auguste**
French, 1841-1919

*A Girl Reading*, 1891
Oil on canvas
16³⁄₈ x 12¹¹⁄₁₆ (41.6 x 32.3)
Signed upper right: Renoir.
Number 908

**Renoir, Pierre-Auguste**
French, 1841-1919

*A Girl with a Fan*, c. 1881
Oil on canvas
25⁹⁄₁₆ x 21¼ (65 x 54)
Signed lower left: Renoir.
Number 595

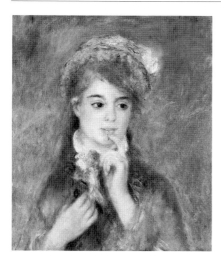

**Renoir, Pierre-Auguste**
French, 1841-1919

*L'Ingénue,* c. 1876
Oil on canvas
22 x 18⅛ (55.8 x 46.1)
Signed upper right: Renoir.
Number 606

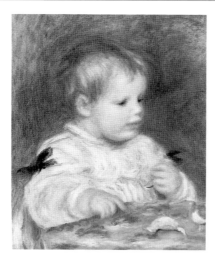

**Renoir, Pierre-Auguste**
French, 1841-1919

*Jacques Fray,* 1904
Oil on canvas
16⅝ x 13⁵⁄₁₆ (42.2 x 33.8)
Signed and dated upper right:
Renoir 04.
Number 600

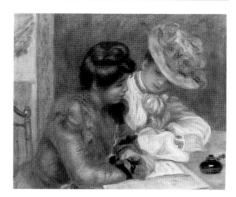

**Renoir, Pierre-Auguste**
French, 1841-1919

*The Letter,* c. 1895-1900
Oil on canvas
25⁹⁄₁₆ x 31¹⁵⁄₁₆ (65 x 81.2)
Signed lower right: Renoir.
Number 583

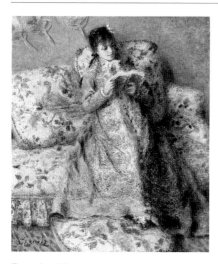

**Renoir, Pierre-Auguste**
French, 1841-1919

*Madame Claude Monet Reading,*
c. 1872
Oil on canvas
24¹⁄₁₆ x 19¹³⁄₁₆ (61.2 x 50.3)
Signed lower left: A. Renoir
Number 612

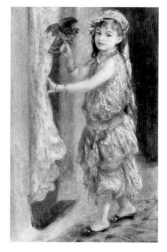

**Renoir, Pierre-Auguste**
French, 1841-1919

*Mademoiselle Fleury in Algerian
Costume,* 1882
Oil on canvas
49¹³⁄₁₆ x 30¾ (126.5 x 78.2)
Signed and dated lower right:
Renoir [8]2.
Number 586

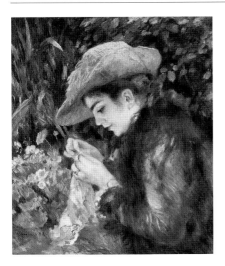

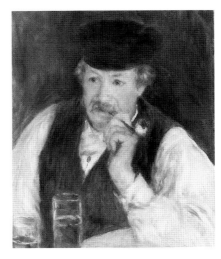

**Renoir, Pierre-Auguste**
French, 1841-1919

*Marie-Thérèse Durand-Ruel Sewing,*
1882
Oil on canvas
25½ x 21³⁄₁₆ (64.8 x 53.8)
Signed and dated lower left:
Renoir. 82.
Number 613

**Renoir, Pierre-Auguste**
French, 1841-1919

*Monsieur Fournaise,* 1875
Oil on canvas
22 x 18½ (55.9 x 47)
Signed and dated right center:
Renoir.75.
Number 55

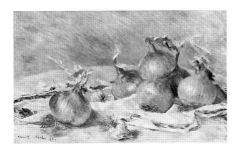

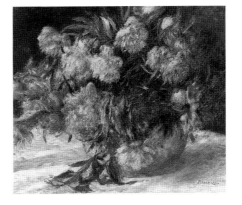

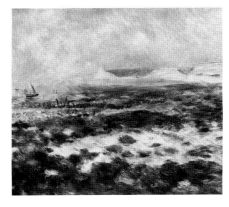

**Renoir, Pierre-Auguste**
French, 1841-1919

*The Onions,* 1881
Oil on canvas
15⅜ x 23⅞ (39.1 x 60.6)
Signed and dated lower left:
Renoir. Naples. 81.
Number 588

**Renoir, Pierre-Auguste**
French, 1841-1919

*Peonies,* c. 1880
Oil on canvas
21⅝ x 25¹¹⁄₁₆ (54.9 x 65.3)
Signed lower right: Renoir.
Number 585

**Renoir, Pierre-Auguste**
French, 1841-1919

*Seascape,* 1883
Oil on canvas
21¼ x 25⁹⁄₁₆ (54 x 65)
Signed and dated lower right:
Renoir. 83.
Number 607

**Renoir, Pierre-Auguste**
French, 1841-1919

*Self-Portrait,* c. 1875
Oil on canvas
15⅜ x 12½ (39.1 x 31.7)
Signed lower right: Renoir.
Number 584

**Renoir, Pierre-Auguste**
French, 1841-1919

*Self-Portrait,* c. 1897
Oil on canvas
16³⁄₁₆ x 13 (41.1 x 33)
Signed upper left: Renoir.
Number 611

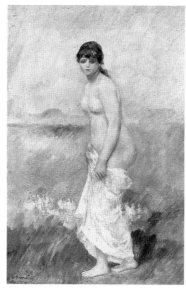

**Renoir, Pierre-Auguste**
French, 1841-1919

*Sleeping Girl with a Cat,* 1880
Oil on canvas
47¼ x 36⁵⁄₁₆ (120.1 x 92.2)
Signed and dated lower right:
Renoir. 80.
Number 598

**Renoir, Pierre-Auguste**
French, 1841-1919

*Standing Bather,* 1887
Oil on canvas
17 x 10⅝ (43.2 x 27.1)
Signed lower left: Renoir.
Number 605

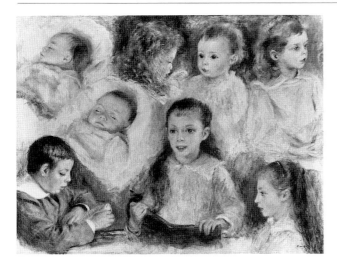

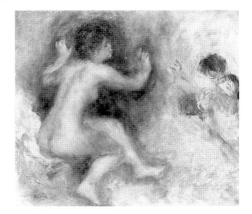

**Renoir, Pierre-Auguste**
French, 1841-1919

*Studies of the Bérard Children,* 1881
Oil on canvas
24⅝ x 32¼ (62.6 x 82)
Signed and dated lower right:
Renoir. 81
Number 590

**Renoir, Pierre-Auguste**
French, 1841-1919

*Study for "Scene from Tannhäuser—*
*Third Act,"* c. 1879
Oil on canvas
21⅝ x 25⅞ (55 x 65.7)
Signed lower left: Renoir.
Number 608

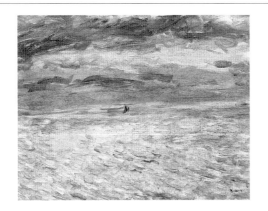

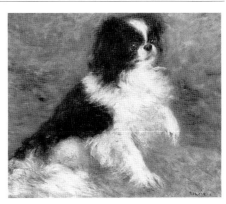

**Renoir, Pierre-Auguste**
French, 1841-1919

*Sunset at Sea,* c. 1883
Oil on canvas
18 x 24 (45.7 x 61)
Signed lower left: Renoir
Number 602

**Renoir, Pierre-Auguste**
French, 1841-1919

*Tama, the Japanese Dog,* c. 1876
Oil on canvas
15⅟₁₆ x 18⅛ (38.3 x 46)
Signed lower right: Renoir.
Number 597

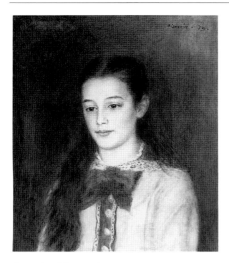

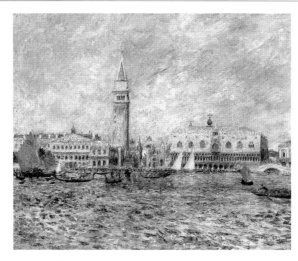

**Renoir, Pierre-Auguste**
French, 1841-1919

*Thérèse Bérard*, 1879
Oil on canvas
22 x 18⁷⁄₁₆ (55.9 x 46.8)
Signed and dated upper right:
Renoir. 79.
Number 593

**Renoir, Pierre-Auguste**
French, 1841-1919

*Venice, the Doge's Palace*, 1881
Oil on canvas
21³⁄₈ x 25¹¹⁄₁₆ (54.3 x 65.3)
Signed and dated lower right:
Renoir. 81.
Number 596

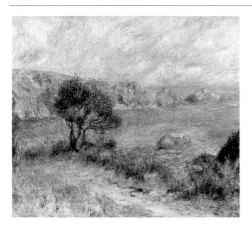

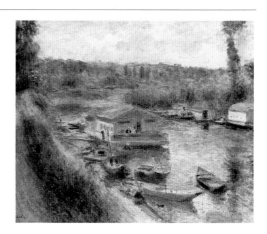

**Renoir, Pierre-Auguste**
French, 1841-1919

*View at Guernsey*, 1883
Oil on canvas
18¹⁄₈ x 22 (46 x 55.9)
Signed and dated lower right:
Renoir. 83.
Number 601

**Renoir, Pierre-Auguste**
French, 1841-1919

*Wash-House on the Lower Meudon*,
1875
Oil on canvas
19³⁄₁₆ x 24¹⁄₄ (50 x 61.3)
Signed lower left: Renoir.
Number 610

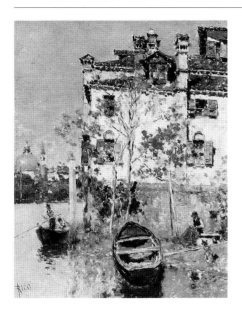

**Rico y Ortega, Martin**
Spanish, 1833-1908

*Venice, House on the Canal*
Oil on panel
5¹⁵⁄₁₆ x 4½ (15.1 x 11.5)
Signed lower left: RICO
Number 842

**Rigaud, Hyacinthe**
French, 1659-1743

*Portrait of a Man,* 1705
Oil on canvas
32¹⁄₁₆ x 25⁵⁄₁₆ (81.5 x 64.4)
Number 953

**Robbins, Raisa**
American (born Russia), 20th Century

*Oriental Dance,* 1944
Oil on canvas
24⁵⁄₁₆ x 30⅛ (61.8 x 76.5)
Signed and dated lower left:
RAiSA/1944
Number 835

**Robbins, Raisa**
American (born Russia), 20th Century

*Russian Country Fair,* 1944
Oil on canvas
22¹⁄₁₆ x 28¼ (56 x 71.8)
Signed and dated lower left:
RAiSA/1944
Number 836

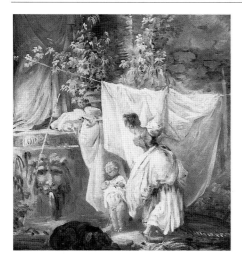

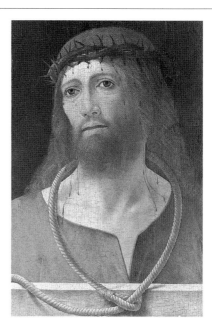

**Robert, Hubert**
French, 1733-1808

*Laundress and Child,* 1761
Oil on canvas
13¹³⁄₁₆ x 12⁷⁄₁₆ (35.1 x 31.6)
Signed, dated, and inscribed center
left: H ROBERTI ROM/1761; signed,
dated, and inscribed center right:
Roberti/Roma/1761
Number 843

**Attributed to**
**Roberti, Ercole dei**
Italian (Ferrarese), c. 1456-1496

*Christ Crowned with Thorns*
Tempera on panel
15⅜ x 10 (39 x 25.5)
Number 929

**Roehn, Adolphe Eugène Gabriel**
French, 1780-1867

*Country Fair,* 1821
Oil on canvas
12¹³⁄₁₆ x 15⅞ (32.5 x 40.4)
Signed and dated lower left:
Roehn/1821
Number 844

**Roqueplan, Camille**
French, 1803-1855

*A Woman and Child with Dogs*
Oil on panel
13¹³⁄₁₆ x 10¼ (35.1 x 26.1)
Signed lower right: Roqueplan
Number 845

**Rossi, Lucio**
French (born Italy), 1846-1913

*A Young Woman Reading,* 1875
Oil on panel
9½ x 7⅜ (24.2 x 18.7)
Signed and dated lower left:
Lucio Rossi 75–
Number 846

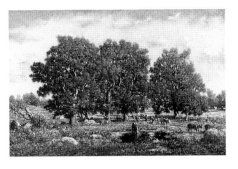

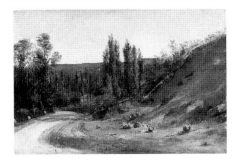

**Rousseau, Théodore**
French, 1812-1867

*Landscape*
Oil on panel
8½ x 11⅝ (21.7 x 29.6)
Signed lower left: TH. Rousseau.
Number 849

**Rousseau, Théodore**
French, 1812-1867

*A Landscape with Oaks and Cows*
Oil on panel
6¹³⁄₁₆ x 10¼ (17.3 x 26)
Signed lower left: TH·Rousseau
Number 848

**Rousseau, Théodore**
French, 1812-1867

*A Road in the Jura*
Oil on canvas
8½ x 12¾ (21.7 x 32.4)
Signed lower left: TH·R
Number 847

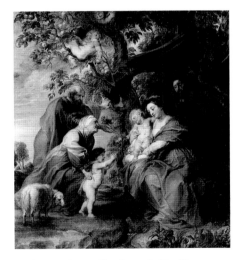

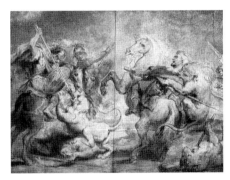

**Rubens, Peter Paul, and Studio**
Flemish, 1577-1640

*The Holy Family under an Apple Tree,*
c. 1632
Oil on panel
42¹⁄₁₆ x 38 (106.9 x 96.5)
Number 950

**After
Rubens, Peter Paul**
Flemish, 1577-1640

*Lion Hunt*
Oil on panel
17⁹⁄₁₆ x 24 (44.7 x 61)
Number 850

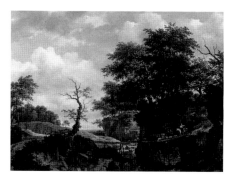

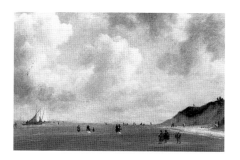

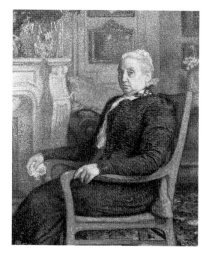

**Ruisdael, Jacob van**
Dutch, 1628/29-1682

*Landscape with Bridge, Cattle, and Figures,* c. 1660
Oil on canvas
37⅝ x 51⅟₁₆ (95.6 x 129.7)
Signed lower right: JR [monogram]
Number 29

**Follower of
Ruisdael, Jacob van**
Dutch, 1628/29-1682

*View on the Seashore*
Oil on canvas
15¾ x 24 (40.1 x 61)
Number 851

**Rysselberghe, Théo van**
Belgian, 1862-1926

*Madame Monnom,* 1900
Oil on canvas
46⅟₁₆ x 35⅞₁₆ (117 x 90)
Signed and dated lower left:
TVR [monogram] 1900
Number 1967.2

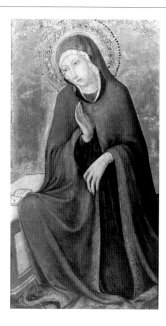

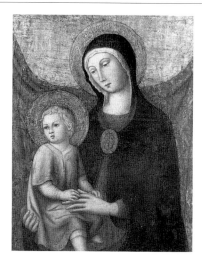

**In the style of
Sano di Pietro**
Italian (Sienese), 1406-1481

*The Virgin Annunciate*
Oil and tempera on fabric and panel
13¹⁵⁄₁₆ x 6¹⁵⁄₁₆ (35.4 x 17.6)
Gift of the Executors of Governor
Lehman's Estate and the Edith and
Herbert Lehman Foundation
Number 1968.303

**After
Sano di Pietro**
Italian (Sienese), 1406-1481

*Virgin and Child*
Oil and tempera on panel
22⅛ x 17¼ (56.2 x 43.8)
Bequest of May H. Salinger
Number 1971.25

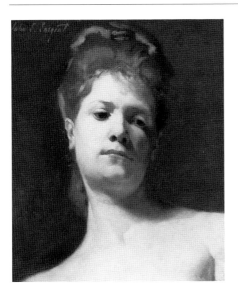

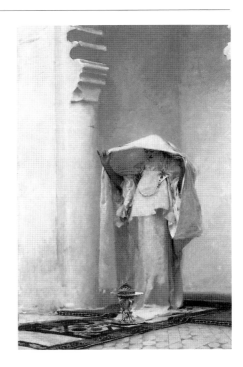

**Sargent, John Singer**
American, 1856-1925

*Blonde Model,* c. 1877
Oil on canvas
17¹⁵⁄₁₆ x 14¹⁵⁄₁₆ (45.6 x 37.9)
Signed and inscribed upper left:
à mon ami Lacombe/John S. Sargent
Number 574

**Sargent, John Singer**
American, 1856-1925

*Fumée d'ambre gris,* 1880
(Smoke of Ambergris)
Oil on canvas
54¾ x 35¹¹⁄₁₆ (139.1 x 90.6)
Signed and inscribed lower right:
John S. Sargent Tanger; pentimento
of signature and inscription lower
center: John S. Sargent Tanger
Number 15

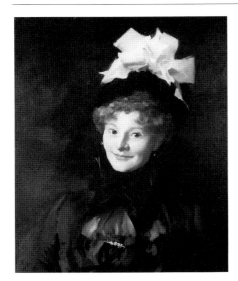

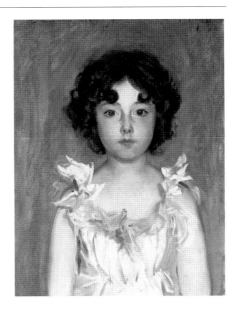

**Sargent, John Singer**
American, 1856-1925

*Madame Escudier,* c. 1882-84
Oil on canvas
28¾ x 23½ (73 x 59.7)
Signed and inscribed upper left:
à Madame Escudier/John S. Sargent
Number 581

**Sargent, John Singer**
American, 1856-1925

*Mademoiselle Jourdain,* 1889
Oil on canvas
23⅝ x 17¹¹⁄₁₆ (60 x 44.9)
Signed, dated, and inscribed across
top: à mon amie Madame Jourdain
John S. Sargent/89
Number 576

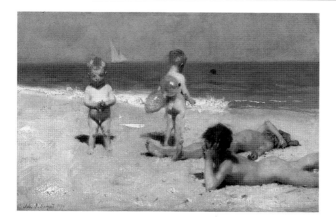

**Sargent, John Singer**
American, 1856-1925

*Neapolitan Children Bathing,* 1879
Oil on canvas
10⁹⁄₁₆ x 16³⁄₁₆ (26.8 x 41.1)
Signed and dated lower left:
John S. Sargent 1879
Number 852

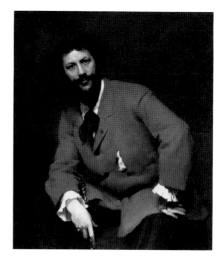

**Sargent, John Singer**
American, 1856-1925

*Portrait of Carolus-Duran,* 1879
Oil on canvas
46 x 37¹³⁄₁₆ (116.8 x 96)
Signed, dated, and inscribed upper
right: à mon cher maître M. Carolus-
Duran, son élève affectionné/John S.
Sargent. 1879
Number 14

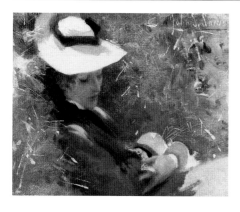

**Sargent, John Singer**
American, 1856-1925

*Resting,* c. 1875
Oil on canvas
8½ x 10⁹⁄₁₆ (21.6 x 26.8)
Signed upper right: John S. Sargent
Number 579

**Sargent, John Singer**
American, 1856-1925

*A Road in the South,* c. 1878-84
Oil on canvas
12¹³⁄₁₆ x 18⅛ (32.5 x 46)
Number 577

**Sargent, John Singer**
American, 1856-1925

*Staircase,* c. 1878
Oil on canvas
21⅞ x 16⅛ (55.6 x 41)
Number 582

**Sargent, John Singer**
American, 1856-1925

*A Street in Venice,* c. 1880-82
Oil on canvas
29⁹⁄₁₆ x 20⅝ (75.1 x 52.4)
Signed and inscribed lower right:
John S. Sargent/Venise
Number 575

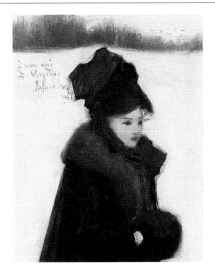

**Sargent, John Singer**
American, 1856-1925

*A Venetian Interior,* c. 1880-82
Oil on canvas
19¹⁄₁₆ x 23¹⁵⁄₁₆ (48.4 x 60.8)
Signed and inscribed lower right:
To my friend J. C. CAZIN/
John S. SARGENT
Number 580

**Sargent, John Singer**
American, 1856-1925

*Woman with Furs,* c. 1880-85
Oil on canvas
11⁵⁄₁₆ x 8¾ (28.7 x 22.2)
Signed and inscribed upper left:
à mon ami/[?] Vergèses/John
S. Sarg/ent
Number 578

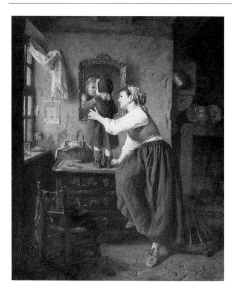

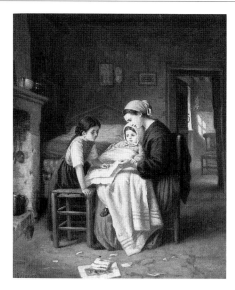

**Seignac, Paul**
French, 1826-1904

*Mother and Child before a Mirror*
Oil on panel
18⅛ x 14¹⁵⁄₁₆ (46.1 x 37.9)
Signed lower right: Seignac.
Number 854

**Seignac, Paul**
French, 1826-1904

*A Sick Child*
Oil on panel
16¹⁄₁₆ x 12¹¹⁄₁₆ (40.8 x 32.2)
Signed lower left: Seignac.
Number 853

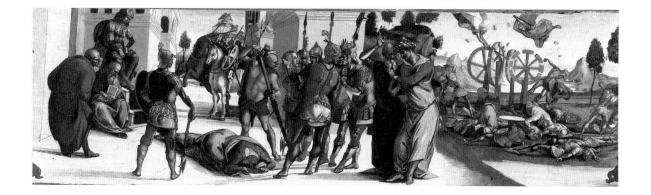

**Signorelli, Luca**
Italian (Tuscan), c. 1450-1523

*The Martyrdom of Saint Catherine of Alexandria,* c. 1498
Oil and tempera on panel
11⅝ x 36⅜ (29.6 x 92.4)
Number 952

**Sisley, Alfred**
French, 1839-1899

*Apples and Grapes in a Basket*
Oil on canvas
18⅛ x 24¹/₁₆ (46 x 61.2)
Signed lower right: Sisley.
Number 543

**Sisley, Alfred**
French, 1839-1899

*Banks of the Seine*
Oil on canvas
21³/₁₆ x 28⅞ (53.9 x 73.4)
Signed lower left: Sisley.
Number 534

**Sisley, Alfred**
French, 1839-1899

*Hampton Court*, 1874
Oil on canvas
14¹⁵/₁₆ x 21¹³/₁₆ (37.9 x 55.4)
Signed and dated lower left: Sisley. 74
Number 560

**Sisley, Alfred**
French, 1839-1899

*Landscape: Snow Scene*, 1891
Oil on canvas
23¼ x 32½ (59.1 x 82.6)
Signed and dated lower left: Sisley. 91
Number 545

**Smith, Henry Pember**
American, 1854-1907

*Village Landscape*, 1881
Oil on canvas
10¹⁵/₁₆ x 14⁵/₁₆ (27.8 x 36.4)
Signed and dated lower left:
HENRY P. SMITH 1881
Number 856

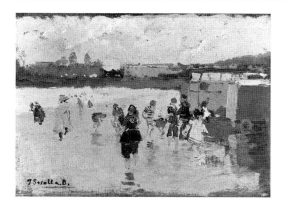 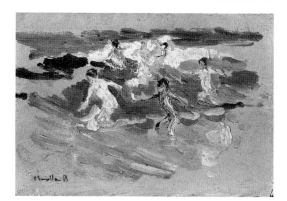

**Sorolla y Bastida, Joaquin**
Spanish, 1863-1923

*Beach Scene*
Oil on panel
5⁵⁄₁₆ x 7⁹⁄₁₆ (13.6 x 19.2)
Signed lower left: J Sorolla. B.
Gift of Harding F. Bancroft
in memory of his wife,
Jane Northrop Bancroft, 1984
Number 1984.166

**Sorolla y Bastida, Joaquin**
Spanish, 1863-1923

*Children Bathing in the Sea*
Oil on panel
3⁵⁄₁₆ x 4¾ (8.5 x 12)
Signed lower left: J Sorolla B
Gift of Harding F. Bancroft
in memory of his wife,
Jane Northrop Bancroft, 1984
Number 1984.165

 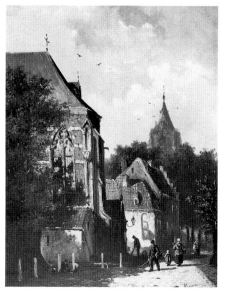

**Springer, Cornelis**
Dutch, 1817-1891

*Amsterdam Street*
Oil on panel
12¼ x 9 ¹⁄₁₆ (30.9 x 23)
Signed lower right: C Springer
[CS monogram]
Number 857

**Springer, Cornelis**
Dutch, 1817-1891

*Amsterdam Street*
Oil on panel
12¹⁄₁₆ x 8¹⁵⁄₁₆ (30.7 x 22.8)
Signed lower right: C Springer
[CS monogram]
Number 858

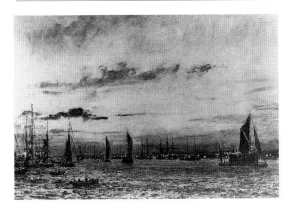

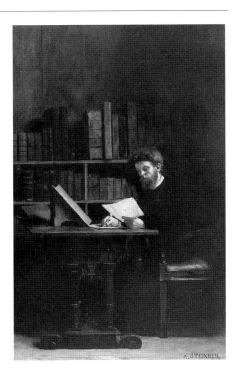

**Steer, Philip Wilson**
British, 1860-1942

*Harbor Scene at Sunset*, 1913
Oil on canvas
23⅞ x 36⅛ (60.6 x 91.8)
Signed and dated lower right:
P W Steer 1913
Number 36

**Steinheil, Auguste**
French, 1814-1885

*The Bibliophile*
Oil on panel
9¹¹⁄₁₆ x 6⅜ (24.6 x 16.2)
Signed lower right: A. STEINHEIL
Number 859

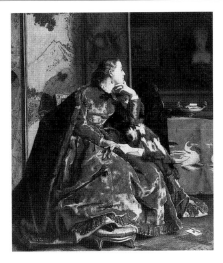

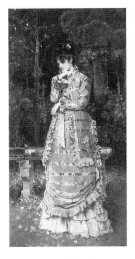

**Stevens, Alfred**
Belgian, 1823-1906

*Au clair de la lune*
(In the Moonlight)
Oil on panel
10⅝ x 8⁷⁄₁₆ (27 x 21.5)
Signed lower left:
AStevens· [AS monogram]
Number 864

**Stevens, Alfred**
Belgian, 1823-1906

*The Blue Dress*
Oil on panel
12⁹⁄₁₆ x 10¼ (31.9 x 26)
Signed lower right: Alfred Stevens
Number 865

**Stevens, Alfred**
Belgian, 1823-1906

*Fall*
Oil on canvas
46⁹⁄₁₆ x 23 ⁵⁄₁₆ (118.3 x 59.2)
Signed lower left: Alfred Stevens.
Number 870

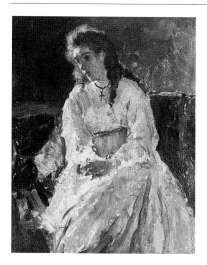

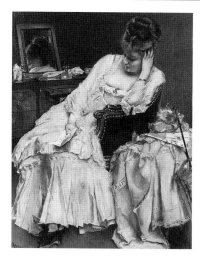

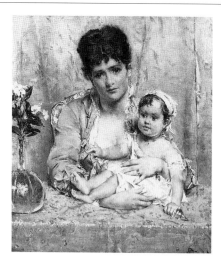

**Stevens, Alfred**
Belgian, 1823-1906

*Girl in White*
Oil on board
12¹¹⁄₁₆ x 9⅝ (32.3 x 24.4)
Signed upper left: AS [monogram]
Number 1028

**Stevens, Alfred**
Belgian, 1823-1906

*Memories and Regrets*
Oil on canvas
24⅛ x 18³⁄₁₆ (61.3 x 46.2)
Signed lower left: AStevens
[AS monogram]
Number 860

**Stevens, Alfred**
Belgian, 1823-1906

*Mother and Child*
Oil on panel
16¹⁵⁄₁₆ x 13⅝ (43.1 x 34.7)
Signed lower right: AStevens.
[AS monogram]
Number 862

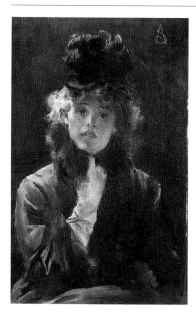

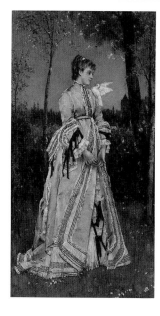

**Stevens, Alfred**
Belgian, 1823-1906

*Le sphinx parisien*
(The Parisian Sphinx)
Oil on panel
10⅝ x 6⅝ (27 x 16.9)
Signed upper right: AS. [monogram]
Number 863

**Stevens, Alfred**
Belgian, 1823-1906

*Spring*
Oil on canvas
46½ x 23⁵⁄₁₆ (118.2 x 59.3)
Signed lower right: Alfred Stevens.
Number 868

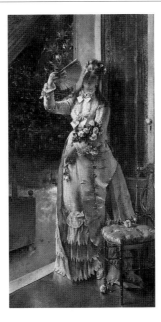

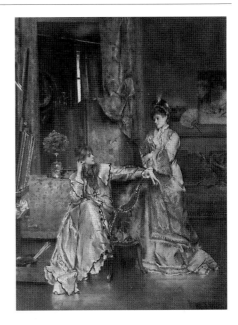

**Stevens, Alfred**
Belgian, 1823-1906

*Summer*
Oil on canvas
46⅜₆ x 23⅝₆ (118.3 x 59.3)
Signed lower left: Alfred Stevens.
Number 869

**Stevens, Alfred**
Belgian, 1823-1906

*The Visit*
Oil on panel
25⅜ x 18⅝₆ (64.5 x 47.1)
Signed lower right: Alfred Stevens.
Number 861

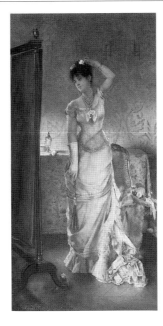

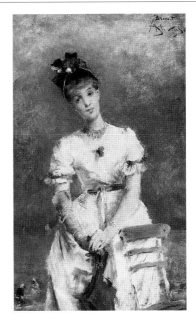

**Stevens, Alfred**
Belgian, 1823-1906

*Winter*
Oil on canvas
46⅜₆ x 23⅝₆ (118.3 x 59.3)
Signed lower left: Alfred Stevens.
Number 867

**Stevens, Alfred**
Belgian, 1823-1906

*Young Girl by the Sea,* 1886
Oil on panel
16 x 9¹¹⁄₁₆ (40.6 x 24.7)
Signed, dated, and inscribed upper
right: à mon jeune ami/Brunet./
AStevens.86 [AS monogram]
Number 866

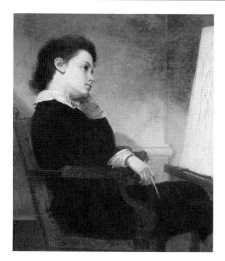

**Story, George Henry**
American, 1835-1922

*The Young Artist*, 1873
Oil on canvas
36 x 29⅛ (91.4 x 74)
Signed and dated lower left:
G H Story/1873
Gift of Mrs. Anson Phelps Stokes
and Mrs. Peter Frelinghuysen
in memory of their parents
Mr. and Mrs. Rodney Procter
Number 1973.14

**Stuart, Gilbert**
American, 1755-1828

*George Washington*, after 1796
Oil on canvas
28¹⁵⁄₁₆ x 24¹⁄₁₆ (73.5 x 61.1)
Number 16

**Stull, Henry**
American (born Canada), 1851-1913

*Kingston*, 1886
Oil on canvas
18 x 27¹⁵⁄₁₆ (45.7 x 71)
Signed and dated lower right:
Henry Stull/1886
Number 905

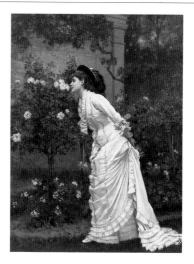

**Teniers, David, the Younger**
Flemish, 1610-1690

*The Card Players*, 1646
Oil on panel
12¹³⁄₁₆ x 16¹⁄₁₆ (32.5 x 40.8)
Signed and dated lower right:
D. Teniers. f/1646–
Number 874

**Tiepolo, Giovanni Battista**
Italian (Venetian), 1696-1770

*The Chariot of Aurora*, c. 1730-35
Oil on canvas
19⅜ x 19⅛ (49.3 x 48.6)
Number 876

**Toulmouche, Auguste**
French, 1829-1890

*A Girl and Roses*, 1879
Oil on canvas
24½ x 17¹¹⁄₁₆ (62.2 x 45)
Signed and dated lower left:
A. Toulmouche. 1879.
Number 877

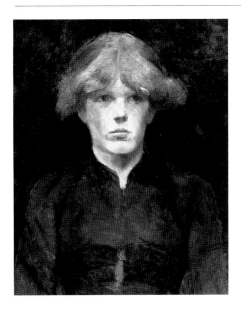

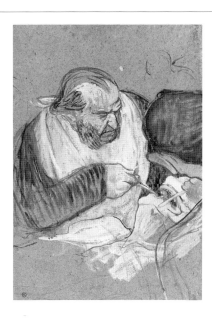

**Toulouse-Lautrec, Henri de**
French, 1864-1901

*Carmen,* 1884
Oil on canvas
20¾ x 16¹/₁₆ (52.8 x 40.8)
Number 525

**Toulouse-Lautrec, Henri de**
French, 1864-1901

*Dr. Péan Operating,* 1891-92
Oil on cardboard
29¹/₁₆ x 19⅝ (73.9 x 49.9)
Signed lower left: HTL [monogram]
Number 567

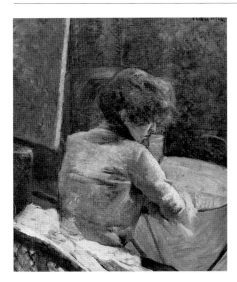

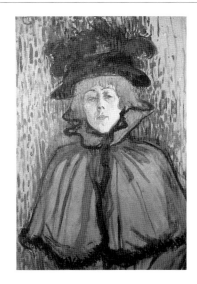

**Toulouse-Lautrec, Henri de**
French, 1864-1901

*In the Studio*
Oil on canvas
22 x 18⁷/₁₆ (55.9 x 46.8)
Signed upper right: HTLautrec
[HTL monogram]
Number 564

**Toulouse-Lautrec, Henri de**
French, 1864-1901

*Jane Avril*
Oil on cardboard, mounted on panel
24⅞ x 16⅝ (63.2 x 42.2)
Signed upper left: HTL [monogram]
Number 566

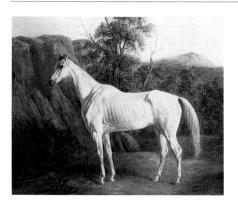
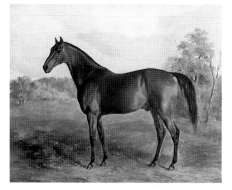

**Troye, Edward**
American (born Switzerland), 1808-1874

*Bolivia,* 1836
Oil on canvas
25⅛ x 30⅛ (63.8 x 76.5)
Number 872

**Troye, Edward**
American (born Switzerland), 1808-1874

*Kentucky Woodpecker,* 1834
Oil on canvas
22½ x 27⁹⁄₁₆ (57.2 x 70)
Signed and dated lower right:
E. Troye/Nov'/1834; inscribed lower
left (not in the artist's hand):
Kentucky Woodpecker
Number 878

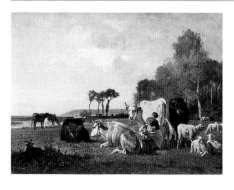
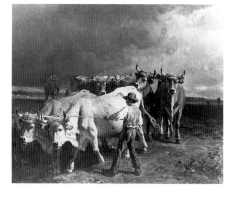
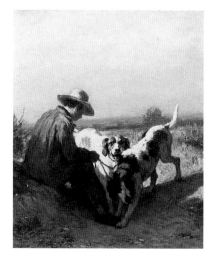

**Troyon, Constant**
French, 1810-1865

*Cattle and Sheep in a Landscape*
Oil on canvas
38⅝ x 52⅞ (98.2 x 134.4)
Signed lower left: C. TROYON.
Gift of the children of
Mrs. E. Parmalee Prentice
Number 1962.152

**Troyon, Constant**
French, 1810-1865

*The Coming Storm,* 1860
Oil on canvas
38⁵⁄₁₆ x 51¹⁄₁₆ (97.3 x 129.8)
Signed and dated lower left:
C. TRoyon. 1860.
Number 56

**Troyon, Constant**
French, 1810-1865

*The Gamekeeper*
Oil on panel
18¼ x 14¹¹⁄₁₆ (46.3 x 37.3)
Signed lower left: C. TRoyon
Number 563

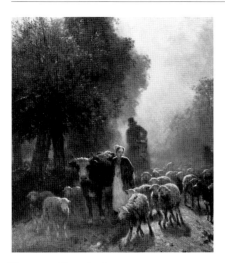

**Troyon, Constant**
French, 1810-1865

*Going to Market on a Misty Morning,*
1851
Oil on panel
25³⁄₁₆ x 20⅝ (65.2 x 52.5)
Signed and dated lower left:
C. TROYON. 1851.
Number 880

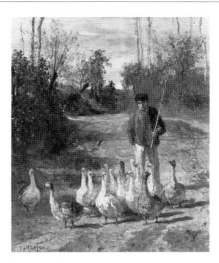

**Troyon, Constant**
French, 1810-1865

*The Gooseherd*
Oil on panel
18¼ x 14¹¹⁄₁₆ (46.4 x 37.4)
Signed lower left: C. TRoyon
Number 550

**Troyon, Constant**
French, 1810-1865

*Saint-Cloud*
Oil on canvas
15¹⁄₁₆ x 18⁵⁄₁₆ (38.3 x 46.6)
Number 536

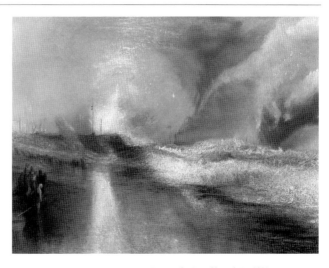

**Turner, Joseph Mallord William**
British, 1775-1851

*Rockets and Blue Lights (Close at
Hand) to Warn Steamboats of Shoal
Water,* 1840
Oil on canvas
36¹⁄₁₆ x 48⅛ (91.8 x 122.2)
Number 37

**Ugolino da Siena (Ugolino di Nerio,
called Ugolino da Siena)**
Italian (Sienese), active 1317-1327

*Virgin and Child with Saints Francis,
Andrew, Paul, Peter, Stephen, and
Louis of Toulouse*
Tempera on panel
137⁷⁄₁₆ x 64⁷⁄₁₆ (341.4 x 163.7)
Number 1962.148

**Vermeyen, Jan Cornelisz.**
Dutch, c. 1500-1559

*Portrait of Felipe de Guevara,* 1531
Oil on panel
22 x 18¾ (55.9 x 47.6)
Gift of Asbjorn R. Lunde
Number 1982.128

**Vernet, Claude Joseph**
French, 1714-1789

*Coastal Scene in Moonlight,* 1769
Oil on canvas
32 x 51½ (81.3 x 130.8)
Signed and dated lower right:
J. Vernet·f·1769; inscribed lower right
on bales: 4·
Number 1977.17

**Vernier, Emile-Louis**
French, 1829-1887

*Landscape*
Oil on panel
5⁷⁄₁₆ x 8³⁄₁₆ (13.9 x 20.9)
Signed lower right: E Vernier
Number 890

**Veyrassat, Jules Jacques**
French, 1828-1893

*Team in a Hayfield*
Oil on panel
12⅜ x 10¹¹⁄₁₆ (31.4 x 27.1)
Signed lower left: J. Veyrassat.
Number 891

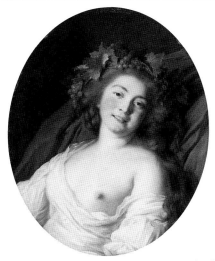

**Vigée-Lebrun, Marie Louise Elisabeth**
French, 1755-1842

*Bacchante*, 1785
Oil on canvas
28⅞ x 23⅜ (73.3 x 59.4)
Signed and dated upper center:
Lse Vge LeBrun f 1785
Number 954

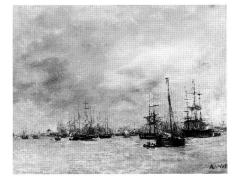

**Vignon, Victor**
French, 1847-1909

*Snow in the Suburbs*
Oil on canvas
9¹¹⁄₁₆ x 12¹³⁄₁₆ (24.7 x 32.5)
Signed lower right: Vr Vignon.
Number 892

**Vollon, Antoine**
French, 1833-1900

*Harbor Scene*
Oil on canvas
7⁹⁄₁₆ x 10⅜ (19.2 x 26.4)
Signed lower right: A. Vollon.
Number 893

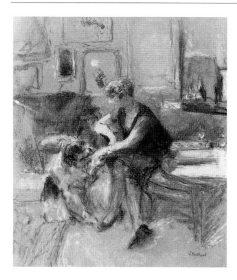

**Vuillard, Edouard**
French, 1868-1940

*Madame Maugey-Rosengart and a Dog in an Interior*, c. 1925
Pastel on paper
27¾ x 22⁹⁄₁₆ (70.5 x 57.3)
Signed lower right: E. Vuillard
Gift of the Executors of Governor
Lehman's Estate and the Edith and
Herbert Lehman Foundation
Number 1968.300

**Watrous, Harry Willson**
American, 1857-1940

*The Chatterers*, 1913
Oil on canvas
28¼ x 24⁵⁄₁₆ (71.8 x 61.8)
Signed, dated, and inscribed lower
right: Watrous/copyright/1914;
dated on left tacking edge: 1913
Number 894

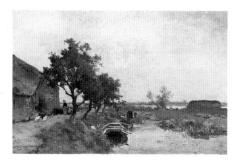

**Weissenbruch, Jan Hendrik**
Dutch, 1824-1903

*Washing Clothes*
Oil on canvas mounted on panel
8⅛ x 12¹⁵⁄₁₆ (20.6 x 32.8)
Signed lower left:
J. H. Weissenbruch f.
Number 895

**Whitcombe, Thomas**
British, c. 1760-1824

*Three British Men-o'-War and Four
Fishing Boats in Breeze Off-Shore*
Oil on canvas
18 x 24 (45.7 x 61)
Signed lower right: TW
Bequest of Peter Ompir
Number 1979.42

**Whitcombe, Thomas**
British, c. 1760-1824

*Three British Men-o'-War and Two
Fishing Boats in Breeze Off-Shore*
Oil on canvas
18 x 24 (45.7 x 61)
Signed lower right: TW
Bequest of Peter Ompir
Number 1979.41

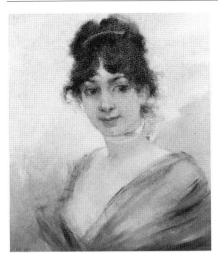

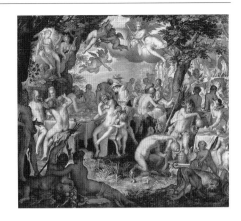

**Willette, Adolphe-Léon**
French, 1857-1926

*Young Woman*
Oil on canvas
21⅜ x 18³/₁₆ (54.3 x 46.2)
Signed lower left: Willette
Number 898

**Worms, Jules**
French, 1823-1914

*Garde national et une femme*
(National Guardsman with a Woman)
Oil on panel
15¾ x 12⁹/₁₆ (40 x 31.9)
Signed lower right: J Worms
Number 899

**Wtewael, Joachim**
Dutch, 1566-1638

*The Wedding of Peleus and Thetis,*
1612
Oil on copper
14¼ x 16½ (36.5 x 42)
Dated lower right: 1612
Number 1991.9

**Zamacois y Zabala, Eduardo**
Spanish, 1842/3-1871

*Platonic Love,* 1870
Oil on panel
12¹¹/₁₆ x 9⅜ (32.3 x 23.8)
Signed and dated lower right:
Zamacoïs·70
Number 900

**Zamacois y Zabala, Eduardo**
Spanish, 1842/3-1871

*Valetaille,* 1866
Oil on panel
12¹³/₁₆ x 9⁷/₁₆ (32.6 x 24)
Signed and dated lower left:
E⁰ ZAMACOIS.66.
Number 901

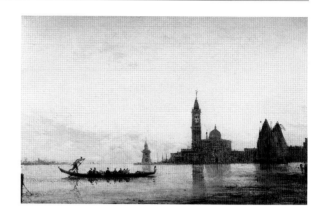

**Ziem, Félix**
French, 1821-1911

*The Doge's Palace, Venice,* c. 1842
Oil on canvas
21¹³⁄₁₆ x 31⅝ (55.4 x 80.3)
Signed lower left: Ziem.
Number 902

**Ziem, Félix**
French, 1821-1911

*The Grand Canal, Venice*
Oil on panel
14¹³⁄₁₆ x 22¼ (37.7 x 56.5)
Signed lower right: Ziem.
Number 903

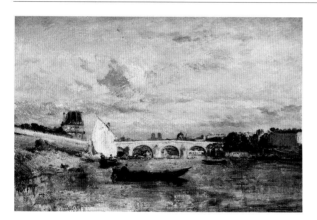

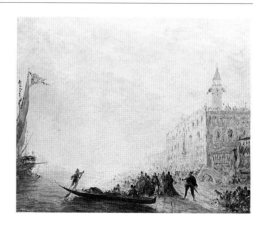

**Ziem, Félix**
French, 1821-1911

*Le Pont Royal, Paris,* c. 1859
Oil on panel
9⁹⁄₁₆ x 14⁵⁄₁₆ (24.3 x 36.4)
Signed lower right: Ziem.
Number 904

**Ziem, Félix**
French, 1821-1911

*Sunset on the Grand Canal*
Oil on panel
23³⁄₁₆ x 28¾ (58.9 x 73)
Signed lower left: Ziem.
Bequest of Madeleine Dahlgren
Townsend
Number 1982.12

| | |
|---|---|
| *Lady Seated* | Goupil, Jules Adolphe |
| *Lady with a Guitar* | Madrazo y Garreta, Raimundo de |
| *A Lady with Flowers* | Heilbuth, Ferdinand |
| *The Lamentation* | Provost, Jan, the Younger |
| *Landscape* | Daubigny, Charles-François |
| *Landscape* | Diaz de la Peña, Narcisse |
| *Landscape* | Dupré, Jules |
| *Landscape* | Guillaumin, Armand |
| *Landscape* | Pokitonow, Ivan |
| *Landscape* | Rousseau, Théodore |
| *Landscape* | Vernier, Emile-Louis |
| *Landscape: Snow Scene* | Sisley, Alfred |
| *Landscape with a Church* | Harpignies, Henri |
| *Landscape with a River* | Harpignies, Henri |
| *Landscape with Bridge, Cattle, and Figures* | Ruisdael, Jacob van |
| *Landscape with Cattle* | Day, Horace Talmage |
| *A Landscape with Oaks and Cows* | Rousseau, Théodore |
| *Landscape with Sheep* | Jacque, Charles |
| *Landscape with the Voyage of Jacob* | Claude Lorrain |
| *Lane to the Village* | British School, 19th Century |
| *Laundress and Child* | Robert, Hubert |
| *La lecture à la convalescente* | Franquelin, Jean-Augustin |
| *The Letter* | Renoir, Pierre-Auguste |
| *The Levee* | Cabot, Edward Clark |
| *Lion Hunt* | Rubens, Peter Paul, copy after |
| *Little Girl with a Pear* | Hassam, Frederick Childe |
| *The Loir at Poncé* | Maufra, Maxime |
| *Louise Harduin in Mourning* | Corot, Camille |
| *The Louvre from the Pont Neuf* | Pissarro, Camille |
| *Lucretia* | Gossaert, Jan, school of |
| *Madame Claude Monet Reading* | Renoir, Pierre-Auguste |
| *Madame Dugazon* | Drölling, Martin |
| *Madame Escudier* | Sargent, John Singer |
| *Madame Leclanche* | Boldini, Giovanni |
| *Madame Maugey-Rosengart and a Dog in an Interior* | Vuillard, Edouard |
| *Madame Monnom* | Rysselberghe, Théo van |
| *Madame Seymour* | Friant, Emile |
| *Mademoiselle Fleury in Algerian Costume* | Renoir, Pierre-Auguste |
| *Mademoiselle Jourdain* | Sargent, John Singer |
| *La Madrileña* | Goya y Lucientes, Francisco José de, attributed to |
| *Malvern Hall* | Constable, John |
| *Man Reading* | Meissonier, Ernest |
| *A Man Reading* | Rijn, Rembrandt Harmensz. van, school of |
| *Marie-Thérèse Durand-Ruel Sewing* | Renoir, Pierre-Auguste |
| *Marine* | Quartley, Arthur |
| *Marsh at Boves, near Amiens* | Corot, Camille, follower of |
| *The Martyrdom of Saint Catherine of Alexandria* | Signorelli, Luca |
| *A Mass* | Lucas y Padilla, Eugenio, attributed to |
| *Meadow with Willows, Monthléry* | Corot, Camille, follower of |
| *Memories and Regrets* | Stevens, Alfred |
| *The Merciless Bailiff* | Morland, George |
| *Méry Laurent Wearing a Small Toque* | Manet, Edouard |
| *The Messenger* | Drölling, Martin |
| *Miss Elizabeth Haig* | Raeburn, Henry |
| *Miss Linley and Her Brother* | Gainsborough, Thomas |
| *Mist on the River* | Cazin, Jean-Charles |
| *Mr. and Mrs. Clark* | Clemens, Paul Louis |
| *Mrs. Clark on a Yacht* | Clemens, Paul Louis |
| *Monsieur Caillaux* | Domergue, Jean Gabriel |
| *Monsieur Fournaise* | Renoir, Pierre-Auguste |
| *Moonlit River* | Lépine, Stanislas |
| *The Morning Visit* | Madrazo y Garreta, Raimundo de |
| *Moss Roses in a Vase* | Manet, Edouard |
| *Mother and Child* | Jonghe, Gustave de |

## List of Paintings by Title

122

| | |
|---|---|
| *The Spinning Wheel* | Millet, Jean-François |
| *Spring* | Chéret, Jules |
| *Spring* | Linder, Philippe Jacques |
| *Spring* | Stevens, Alfred |
| *Spring in Giverny* | Monet, Claude |
| *Staircase* | Sargent, John Singer |
| *Standing Bather* | Renoir, Pierre-Auguste |
| *Standing Bishop Saint* | Franceschi, Francesco dei, attributed to |
| *Street in Sainte-Adresse* | Monet, Claude |
| *A Street in Venice* | Sargent, John Singer |
| *Studies of the Bérard Children* | Renoir, Pierre-Auguste |
| *Study for ''The City and Country Beaux''* | Edmonds, Francis William |
| *Study for ''Scene from Tannhäuser—Third Act''* | Renoir, Pierre-Auguste |
| *Study for ''Trumpeter of the Hussars on Horseback''* | Géricault, Théodore |
| *A Sudden Squall at Sea* | Biard, François |
| *Summer* | Stevens, Alfred |
| *Summer Squall* | Homer, Winslow |
| *Sunset at Sea* | Renoir, Pierre-Auguste |
| *Sunset on the Grand Canal* | Ziem, Félix |
| *A Swiss Lake* | Deshayes, Eugène |
| *Tama, the Japanese Dog* | Renoir, Pierre-Auguste |
| *Team in a Hayfield* | Veyrassat, Jules Jacques |
| *Terrace at the Tuileries* | Gogh, Vincent van |
| *Thérèse Bérard* | Renoir, Pierre-Auguste |
| *Three British Men-o'-War and Four Fishing Boats in Breeze Off-Shore* | Whitcombe, Thomas |
| *Three British Men-o'-War and Two Fishing Boats in Breeze Off-Shore* | Whitcombe, Thomas |
| *Tiger* | Barye, Antoine-Louis |
| *Tom Thumb: Peter Brown and His Wife* | Pollard, James |
| *Trees near Barbizon* | Diaz de la Peña, Narcisse |
| *Trompe l'oeil* | Boilly, Louis-Léopold |
| *Trumpeter of the Hussars on Horseback* | Géricault, Théodore |
| *The Tuileries Gardens* | Baré, Edouard |
| *Tulip Fields at Sassenheim, near Leiden* | Monet, Claude |
| *Two Guides* | Homer, Winslow |
| *Two Horses and Riders* | Leighton, Nicholas Winfield Scott |
| *Two Pointers* | Penne, Olivier de |
| *Undertow* | Homer, Winslow |
| *Valetaille* | Zamacois y Zabala, Eduardo |
| *A Venetian Interior* | Sargent, John Singer |
| *Venice, House on the Canal* | Rico y Ortega, Martin |
| *Venice, the Doge's Palace* | Renoir, Pierre-Auguste |
| *View at Guernsey* | Renoir, Pierre-Auguste |
| *View of a Dutch Town* | Maris, Jacob Henricus |
| *View on the Seashore* | Ruisdael, Jacob van, follower of |
| *Village Landscape* | Smith, Henry Pember |
| *Villefranche* | Boudin, Eugène |
| *Virgin Adoring the Child* | Montagna, Bartolomeo |
| *Virgin and Child* | Benvenuto di Giovanni |
| *Virgin and Child* | French School, 15th Century |
| *Virgin and Child* | Sano di Pietro, copy after |
| *The Virgin and Child Enthroned* | Master of the Embroidered Foliage |
| *Virgin and Child Enthroned with Four Angels* | Piero della Francesca |
| *Virgin and Child in a Landscape* | Master of the Legend of Saint Lucy |
| *The Virgin and Child with an Angel* | Master of the Female Half-Lengths |
| *Virgin and Child with Musical Angels* | Master of the Straus Madonna |
| *The Virgin and Child with Saint Dominic, Saint Catherine, and Donor* | Italian School, 14th Century |
| *Virgin and Child with Saint John the Baptist* | Botticelli and studio |
| *Virgin and Child with Saints Francis, Andrew, Paul, Peter, Stephen, and Louis of Toulouse* | Ugolino da Siena |
| *Virgin and Child with Saints John the Evangelist and Paul* | Bergognone, in the style of |
| *Virgin and Child with Two Angels* | Matteo di Giovanni |

## List of Paintings by Title

| | |
|---|---|
| *The Virgin Annunciate* | Sano di Pietro, in the style of |
| *Viscount Hampden* | Gainsborough, Thomas |
| *The Visit* | Stevens, Alfred |
| *The Volunteer's Courtship* | Caldecott, Randolph |
| *Vulcan Presenting Arms to Venus for Aeneas* | Boucher, François |
| *The Warrior* | Fragonard, Jean-Honoré |
| *Wash-House on the Lower Meudon* | Renoir, Pierre-Auguste |
| *Washerwomen* | Boldini, Giovanni |
| *Washerwomen in a Willow Grove* | Corot, Camille |
| *Washing Clothes* | Weissenbruch, Jan Hendrik |
| *Washington's Headquarters, Valley Forge* | American School, 19th-20th Century |
| *The Water Carrier* | Millet, Jean-François |
| *The Wayfarer* | Decamps, Alexandre Gabriel |
| *The Wedding of Peleus and Thetis* | Wtewael, Joachim |
| *West Point, Prout's Neck* | Homer, Winslow |
| *A Windy Day, Place de la Concorde* | Béraud, Jean |
| *Winter* | Stevens, Alfred |
| *Woman* | Hernandez, Daniel |
| *A Woman and Child with Dogs* | Roqueplan, Camille |
| *A Woman in Evening Dress* | Beers, Jan van |
| *Woman in White* | Madrazo y Garreta, Raimundo de |
| *Woman in Yellow* | Jonghe, Gustave de |
| *Woman Seated at a Dressing Table* | French School, 19th Century |
| *Woman Sketching in a Landscape* | Austrian School, 19th Century |
| *Woman Wearing a Hat with a Blue Ribbon* | Goupil, Jules Adolphe |
| *Woman with a Bouquet* | Hernandez, Daniel |
| *Woman with Baby* | Cassatt, Mary Stevenson |
| *Woman with Furs* | Sargent, John Singer |
| *Women in Church* | Douglas, William Fettes |
| *The Women of Amphissa* | Alma-Tadema, Lawrence |
| *Women with Dog* | Bonnard, Pierre |
| *Wood Gatherers: An Autumn Afternoon* | Inness, George |
| *Wooded Grove* | Cook, Clarence G. |
| *Woodland Landscape with a Farm* | Hobbema, Meindert, in the style of |
| *Woodland Scene* | Daubigny, Charles-François |
| *The Young Artist* | Story, George Henry |
| *The Young Card Players* | Le Nain Brothers |
| *Young Christian Girl* | Gauguin, Paul |
| *Young Girl by the Sea* | Stevens, Alfred |
| *Young Woman* | Willette, Adolphe-Léon |
| *A Young Woman Reading* | Rossi, Lucio |